The Boats

—— *The* ——

SOMERSET
LEVELS

The Boats of
— The —
SOMERSET
LEVELS

MIKE SMYLIE

AMBERLEY

To them all!

All photographs are from Watchet Boat Museum Collection unless stated otherwise.

First published 2012

Amberley Publishing
The Hill, Stroud
Gloucestershire, GL5 4EP

www.amberley-books.com

British Library Cataloguing in Publication Data.
A catalogue record for this book is available from the British Library.

ISBN 978 1 4456 0389 6

Typeset in 10pt on 12pt Sabon.
Typesetting and Origination by Amberley Publishing.
Printed in the UK.

Contents

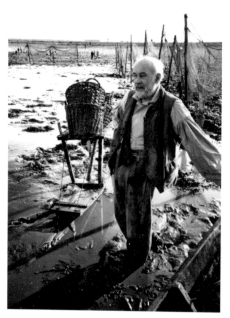
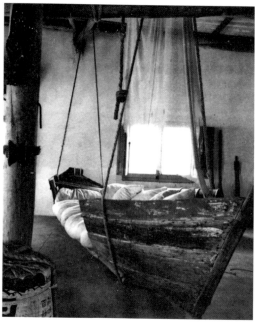

Above left: In John Nash's own words, 'I'm so pleased to get it all out of my head and into print!' Here he is wondering whether it was worth it.

Above right: Though the use of flatners has almost faded from reality these days, there have been alternative uses put forward. Could this be the bed of the future or another use of a decommissioned fishing vessel?

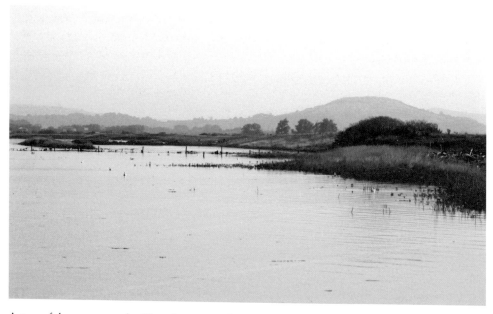

A peaceful scene upon the River Parrett at Black Rock, where Bob Thorne had his putchers. It's hard to imagine that this river was once the home to a vibrant fishery undertaken by various means, including these fish traps and small flat-bottomed vessels.

Introduction and Acknowledgements

Flat-bottom craft have always been fascinating, largely because they appear so simple in their construction at first glance, but beneath this façade they are examples of boatbuilding at its most complex. Throughout the world there are many examples, all of which have some similarity in the construction of the bottom. In Britain, the best examples can be in the boats of the Somerset Levels and Moors, rivers and coastal waters. Thus this book is exclusively about Somerset traditional working craft.

John Nash is equally intriguing, having been the Honorary Curator of the Watchet Boat Museum for a number of years. Living almost overlooking the Museum, and being their computer whizz kid (according to Tony James), he spent three days in March 2011 relating much of what he had learned over the years. Thus this book is mostly down to his expertise, the author merely being the transferrer between his mind and the reader. Therefore, all gratitude for the book's birth must go to John. Commander Gil Mayes also shared some of his experiences building and sailing these craft. Campbell McCutcheon at Amberley was immediately keen when I mentioned the prospect of a book on this subject and has since produced a fine book. Lastly, I must mention my good companion and dog Mono, who died the day I started to write this book. He had travelled all over with me throughout his thirteen years and had shared with me the writing of (and appeared in) many of my fifteen previous books. God rest his loyal soul.

Chapter One

Background, Definition and Evolution of Type

The Somerset Levels and Moors is an area shrouded in both mystery and mythology: a world of water with traditions reaching back into prehistory and a place of legends, such as its associations with Avalon. It is a low area of some 160,000 acres, spread between the Mendip Hills in the north, the Quantocks on its western fringe and the Blackdown Hills to the south. In between, the Polden Hills slice through, dividing much of the area into half. In 1771 Arthur Young described the whole area as 'very large tracts of flat marshy land, half poisoned with wet'. Today, it is not very different.

Although as a whole often just referred to as 'the Levels', these in general occupy the coastal plain stretching from Clevedon in the north down as far as Watchet, while 'the Moors' refer to the inland plain behind the former. The Levels are about 6 metres higher than Mean Sea Level while the Moors are only some 3–3.6 metres higher. Thus, with the highest spring tides over 7 metres above MSL, the whole area has been, as it still is to some extent, prone to flooding, not particularly from the sea but from the increased average rainfall the Levels and Moors receive (700 mm annually) compared to the rest of southern England. Indeed, the whole area is one of a reclaimed landscape.

Humans have made their presence known on these lands since the Palaeolithic era, although much of the area was under water until some 6,000 years ago. A combination of sea regression and the effects of mankind's efforts at drainage has resulted in today's Levels and Moors. Settlements and hill forts have existed on the raised 'islands', such as Glastonbury Tor and Brent Knoll, and throughout the Polden Hills. Smaller mounds of land are called 'burtles'.

Today, various rivers and manmade channels drain the whole area. However, the first attempts to deepen existing water courses and build new drainage channels began in medieval times. Sea defences were built by the abbots of Glastonbury and the bishops of Bath and Wells. The King's Sedgemoor Drain was constructed during the closing years of the eighteenth century, the River Cary being diverted at the same time. Then, in the early 1800s, the first land drainage systems were built, dividing up the land into thousands of fields, the water being taken off into the rhynes, the drain-offs which flowed into the rivers and channels. These rhynes also double up as irrigation channels in summer when water is badly needed for crops.

The principle rivers of the area are the Parrett, Axe, Brue, Huntspill (manmade during the Second World War), Tone, Yeo and Cary, while the King's Sedgemoor Drain is still a major flow-off. Water was pumped away to sea through the various steam

pumping stations that grew up, a few of which still exist as endangered buildings. One, at Westonzoyland, was the first to be built to lift water from the Levels and Moors in 1831 by the Middlezoy, Othery and Westonzoyland Drainage Board. After becoming a derelict building when an adjacent diesel-engined pumping station was built in 1951, the Easton & Amos drainage machine was restored in 1977 by the Westonzoyland Engine Trust. Today, the Trust has bought the building from Wessex Water, has become a charity and now has museum status so that the Grade II listed building is open to the public. Inside are exhibits and various examples of engines and they also give occasional live steam demonstrations. Today, the Environment Agency runs twenty-one pumping stations and countless sluices to keep the Levels and Moors drained. Floods have occurred such as in the winter of 1929/30, but are kept to a minimum.

Many of these waterways around the Levels and Moors have remained important navigable routes since at least Roman times (and probably earlier). Ports sprung up on these rivers to serve the hinterland, an example being Bleadney on the River Axe in the eighth century. Vessels were able to transport goods by water to within three miles of Wells. The Parrett was navigable to Langport in 1600.

The Levels and Moors have been producers of willow, reed, peat and cider for hundreds of years. As a generalisation, the Levels are the producers of the withies and reeds and the Moors the peat. Apples grow well anywhere! However, Cheddar cheese is possibly the best known of all the area's production though certainly not the most prolific. Teazels, as used to raise the nap on woollen cloth, were, and still are, grown on the Levels. These were introduced in the twelfth century and became an important crop, being the only field crop to be used in its pure form in industrial processing, and remains unrivalled even today for dressing the finest cloth. Somerset is the only county in which these are grown, though today there is only one dealer and a few farmers who cultivate small acreages.

On top of all these, apart from general agriculture, fishing, especially for salmon, eels and elvers, has been a way of life for as long as man has been present here. And for all these occupations and pastimes, boats were needed to move the goods around the waterways and to fish from. They became the workhorses of the waterways, even transporting the inhabitants to market one day and maybe to church the next.

Flat-bottomed craft are the obvious choice to move about shallow inland waters. As elsewhere in Europe, these vessels share building traditions with a number of craft such as, among others, the fleet trow from Chesil Beach, the Polish canoe, the Croatian *sandula*, the Italian *sandolo*, the Danish *kag* and *pram* types, the *nacelle* and *bette* of southern France and even the North America *dories*. In the Somerset Levels the workboats were simply known as 'turf boats', 'withy boats', 'Bridgwater flatners' and 'Watchet flatties', the latter two often just referred to as 'river boats' and 'sea boats', and sometimes the latter as Gore boats because they fished out into the entrance to the River Parrett, where an area of shoal is known as 'the Gore'. What they all had in common was the unsophistication in their building because, mostly, they were built by the men, farmers and fishermen, who used them. Flatners of a different, yet still flat-bottom, construction were to be found at Weston-super-Mare and Clevedon. Larger examples of similar vessels are the Severn trow and Bridgwater barge.

In Albany Major's *Early Wars of Wessex* (Poole, 1978) the boats are described as being 'of a three-strake, flat-floored, double-ended build, with a marked 'flare' at bows

and stern which is strongly reminiscent of the Norse longship'. He compares the baler in use as 'an exact pattern of those found with buried ships of the Viking age, carved out of a single block of wood'. At the same time he suggests influence for the centre board as coming from America, which agrees with the suggestions of other writers that these boats were developed from the North American dories. Others say it was the flatner, taken to America by John Cabot aboard his *Matthew* in 1497, which was the forerunner of the dory. While there is no doubt that the Norse invaders settled in parts of Somerset, it would appear more likely that the basic form of these craft evolved out of the log boat, where sewn planking was first added to raise the sides and then one wide plank of elm was used for the bottom instead of the carved-out log. Such flat-bottomed boats were known to be in use in Roman times. The use of clinker planking to create the hull sides is undoubtedly from Scandinavian influence and thus it can be said that the development of the boats of the Somerset Levels is a combination of factors that have led to the end-product, which is a vessel totally suited to the job it is intended for. This is an identical developmental route to that which almost all working boats have taken: a mixture of tradition handed down through generations, the work to be undertaken, the type of shore to be worked from and personal innovations and preferences. At its most basic, the turf boat is perhaps both the simplest and purest of boat forms – a simple flat bottom and two strakes either side, often shaped by the tree they originated from, with the minimal of strengthening.

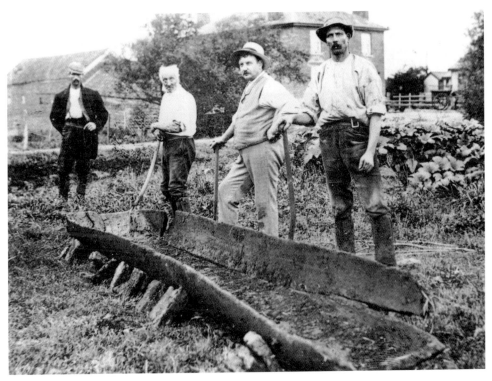

It is thought that the flatner in its basic form was merely an extension of the logboat with built-up planking on either side.

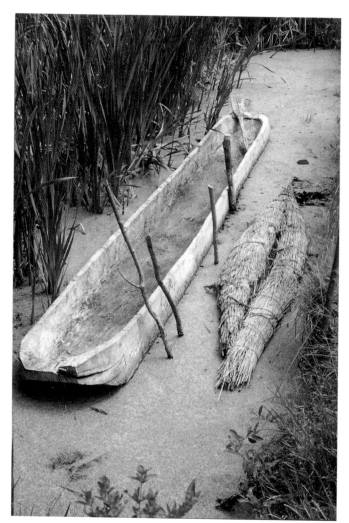

A logboat made at the now-defunct Peat Moors Centre at Shapwick, although the current whereabouts of the vessel is unknown.

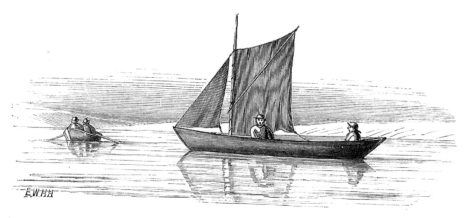

A drawing of a flatner from E. Holdsworth's *Deep-Sea Fishing and Fishing Boats*, 1874.

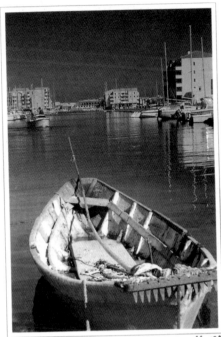

Above left: On the inland waterways of the western end of the Mediterranean coast of France, small boats fish. These are known as *nacelles* or *bettes* and are similar in construction to flatners.

Above right: Here it is possible to see a similarity in the internal strengthening. In latter years they too have been built using plywood and modern glues.

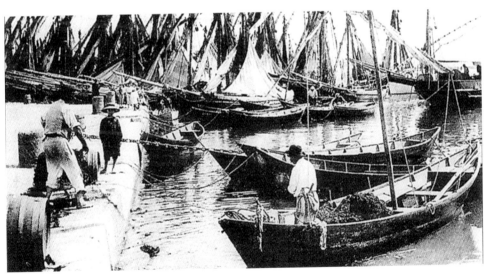

The *nacelles* were prolific around these inland waterways known as 'etangs'. (*Courtesy of the Mike Smylie Collection*)

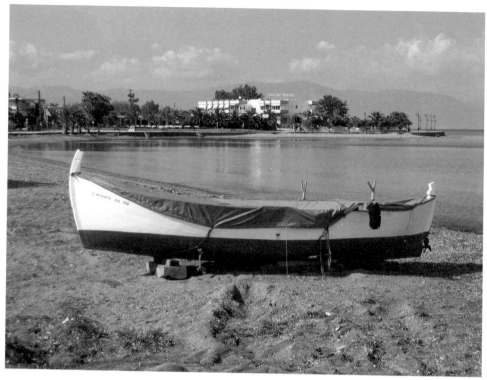

In Greece a similar flat-bottomed boat was the *kourita*, which was introduced into the country from Asia Minor when the Turks over-ran the Greek-controlled lagoons around the city of Smyrna. (*Photo by author*)

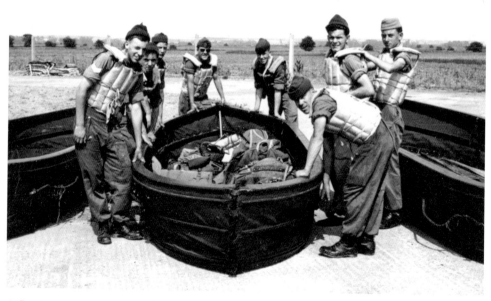

A flat-bottomed assault vessel of the type used by the army from D-Day up to at least 1960.

Chapter Two

The Turf Boat

There's something so romantic about the warming sight of peat glowing in the hearth, the gentle flicker of the flames and, most of all, the smell. More so than a log fire, though of course there are those that say the sweet scent of pine doesn't compare with that of earthy peat. I disagree. I have a friend in Scotland who digs and dries his own peat and we've spent many an evening, wee drams in hand, wiling away the hours with the fire warming our hearts, the whisky (peaty west coast of course) enriching our minds.

Sandwiched between the Mendip and Polden hills is an area of the Moors where peat has been dug out of the ground since at least Roman times and probably before. The main areas are Shapwick and Meare heaths, both sitting astride opposite sides of the southern drain of the Huntspill river and at Westhay Moor, to the north across the River Brue which flows through, bringing the rich minerals down with it. However, it wasn't until the drainage of these areas was carried out in medieval times that large-scale peat production started. The majority of this was used to heat homes.

The peat itself is much older. Six thousand years ago, it was only a relatively short time since the whole area had been under the sea following the end of the last Ice Age. Here, plants had begun to gain a foothold in the mineral-rich water which had run off the forested hills to the north. These plants didn't survive for long and fell into the semi-stagnant water, where the lack of oxygen prevented them rotting down. An organic matter built up, added to after each new plant died in the same way. Over thousands of years this organic layer became peat, made up mostly of sedge grasses. Thus, unlike much of the peat in western Ireland and the uplands of Wales, as well as that from my friend's field in Scotland's Kintyre, this peat was not acid-rich, having been flushed by the mineral rich water washing down from the limestone hills.

In time the rainwater washed away some of the minerals, so that today it is easy to recognise several layers of different peats. Under the topsoil is a light peat and below that is the best black peat, known as the true Somerset sedge peat. This, when dug and dried, forms hard blocks which were once mostly used for burning. Today, with few using it as a fuel, most of the peat extracted is used for garden peat, this one being a coarse-graded peat. Even deeper down is the fenwood peat, which consists of the remains of various trees such as willow, birch and alder. This again is a useful garden peat. At the very bottom, being some 6,500 years old, is the first layer, which was formed mostly from reeds and, being unsuitable to cut as blocks, was left untouched until industrial production extracted it to be used as a fine garden peat.

Industrial peat production began in the 1960s, when a major market developed to satisfy the growing demand for horticultural peat. At the same time peat burning decreased because of central heating and other, easier, forms of obtaining heating materials such as coal and logs. Prior to this, and stretching right back into the mists of time, peat digging – or turfing, as it was known – was a common job around the Moors. It was certainly used as a source of heat back in Roman times and its documented history goes back to the twelfth century, when the Abbot of Glastonbury had enough peat to heat all the hearths in Glastonbury. This, it transpired, he had stolen from the supplies of the Bishop of Wells!

In more recent times it was a job involving the whole family. The men would dig it out and dry it using specialised tools such as peat-digging spades and choppers. It was a laborious manual job, as my friend once explained to me: back-breaking and heavy work. Then the women and children would stack it to dry out or load it up to be carried off to higher ground, or the *bach* as they called it. Specific words represented each of the stages of processing the blocks. Firstly, *mumps* were dug out which measured 12 by 10 by 8 inches. After a short drying out, these would be divided into three *turves* with the chopper and left to dry for a week or so. Once firm enough to handle, these were stacked into *winrows* or long rows some six turves high, the first row on end and the other five flat. However, with the first layer of the winrow close to the ground, these were the slowest to dry. Thus large, airy beehive-shaped structures called *ruckles* were built, the drier turves in the middle and the wetter on the outside. These would remain on the moor until dry, after which they were transported to a bach, away from the winter flooding, where they were *ricked* for storage until needed. Those not quite dry would be built into *hyles* of fourteen turves, carefully positioned to ensure thorough drying. Small ruckles were *tates*. In all, it took about twelve weeks from digging until the completion of the drying process.

It was the turf boat that carried the peat – or, more correctly, the turves – around the Levels, as well as being a general workboat about the farm, carrying all sorts of farm products, a bit like the farmer's 4x4 pick-up of today. In general, a Somerset turf boat, as used by the peat farmers to carry their turves around the Levels, especially in winter when the land was flooded, was a double-ended, flat-bottomed boat with acutely flared sides which met at very raked ends. Most appeared to be of a very crude design and construction and were on the whole built on the farms by the farm handyman or local boatbuilder. Looks can be deceiving, though, and these craft were strong, utilitarian and well built. By the 1930s it was rare for any to be built for work although a few replicas have subsequently been built.

Traditionally, they were built of a one-piece bottom from a wide elm tree the boatbuilder had sourced himself locally. All the timber would be obtained this way, for purchasing wood from a merchant was unheard of. Likewise two strakes, or planks, either side, often left with the bark attached, were similarly sourced. The heavy stem and sternpost (the *noses*) were attached to the shaped bottom board – the length of the finished boat being determined by the designed width of this – with the annual rings of the board curving upwards. It is these – the one-piece bottom and solid ends – that suggest an ancestry from the logboat. The first strake is then fitted to the bottom and noses, at an angle of 45 degrees. Then the knees – called *drashels* – cut from crooks of

oak were fitted, with the second strake then being added. This was cut to almost a taper to keep the sheer as low as possible at both ends, and a thin rubbing strake was added at the top. Floors with limber holes in the middle – *hrungs* – were added to strengthen the bottom. Nothing else was needed: no thwarts, no rudder, no anything. Finished boats were in the region of 17 feet long overall and were tarred inside and out. Smaller boats of a proportionately similar ratio between length and beam were possible and almost every boat in the Levels was built by various boatbuilders in the same way. It has been said that boats up to 35 feet long were built, but no details are available.

When being moved about the waterways, they were usually either tracked along the riverbank or poled along the flooded area or canal with a pole with a spade-type handle and a forked, wrought iron end.

Each dried turf weighed approximately two pounds and a typical turf boat was capable of carrying 500 turves, weighing almost half a ton. For such a small 17-foot vessel, this was quite a load. However, it was the spooned shape of the vessel that made it so stable and capable of carrying a heavy load. This, after all, was its sole *raison d'etre*.

Today, some of the land around the River Brue belies the appearance of dereliction, although the dark oily scars are the remains of the peat beds, where the green grass was pared away to expose what became an underlying wealth to some local landowners once industrialisation took hold. Before that it was survival, as much of life was on the Levels. However, with the process of digging and, especially, the drying being labour-intensive and costly, it was left to only those few with the money to finance the purchase of a peat-cutting machine, first introduced in 1963. Coal, brought in from South Wales since the mid-eighteenth century as Abbey and Neath Bank coal, became cheaper as transport around the Levels improved with canal building in the late eighteenth century. With the expansion of the rail network in the second half of the eighteenth century, peat burning further declined. Finally, with a fast-developing road system in the 1920s, the turf boats were left to rot alongside waterways and rhynes. Small communities were broken up as they went off to search for other work. Ironically, the railways themselves became redundant so that they too were shut down, and by the mid-1960s peat cutting for fuel was almost extinct.

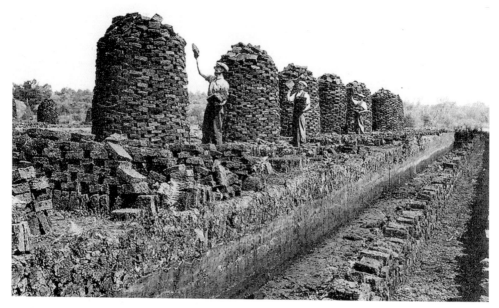

Ruckles – structures built with turves to complete their drying process – were once a common sight around the Moors.

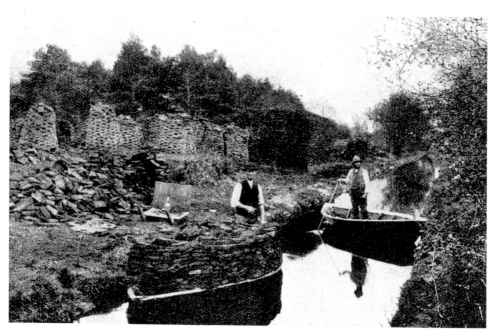

Here one turf boat is fully loaded and another ready to load from the ruckles close by the waterway.

A panoramic view over the Somerset Levels taken in the winter of 2011. (*Photo by author*)

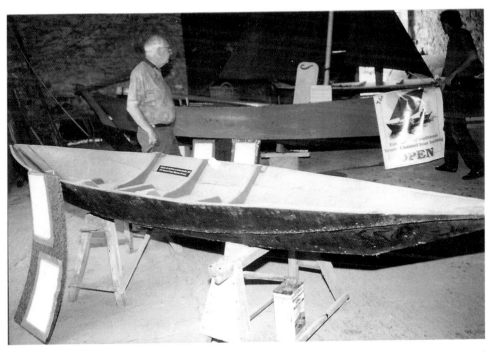

At the Bristol Shanty Festival in 1986 the Coventry Boatbuilders built a two-thirds scale turf boat in a day. This was later raffled and the winner, not wishing to carry it home, donated it to the local museum; eventually it ended up in the Watchet Boat Museum.

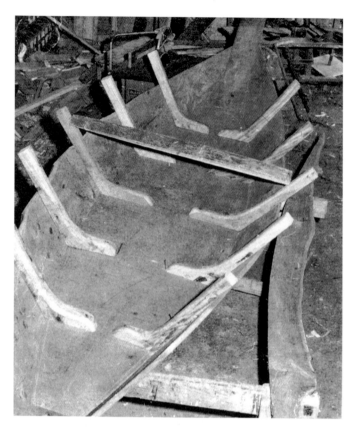

Building a turf boat.
In basic terms, the turf
boat is probably one of
the simplest boat forms,
though highly efficient for
its purpose.

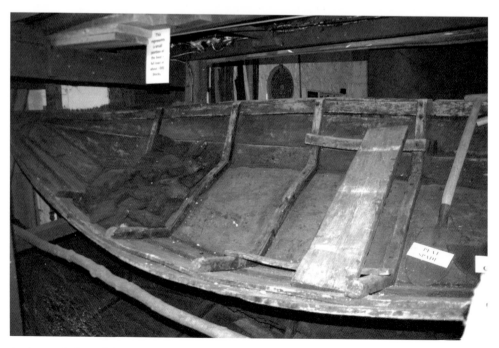

An internal view of the turf boat on display at the Watchet Boat Museum.

Chapter Three

The Withy Boat

The withy boat appears to be an evolutionary sibling of the turf boat, though one that, over time, surpassed its parental development. Like the turf boat, however, it was built with specific work in mind.

Willow (genus *Salix*) has probably been grown in the wetlands of Somerset since the Bronze Age, and possibly earlier. Since the nineteenth century there has been intensive growing to satiate the flourishing basket-making industry of the area. It thrives in areas that are constantly moist and can easily cope with both an excess of flood water and the absolute opposite at times of drought. I remember planting several willows outside my house in Anglesey many years ago and being amazed at how they grew with the most limited – if any at all – attention. The occasional harvesting for the shoots and annual clearing of the accumulating grass around the base was all they got. But they thrived whereas oaks failed, cabbages were ravaged by caterpillars and fruit hardly fruited.

Drive around the Levels in autumn and winter and it is rare not to see a pollarded willow. These are often used as landmarks at times of flood. Pollarding is the annual harvesting, when the shoots are cut to encourage new growth. These are used for making hurdles, thatching spars and firewood. What is left is a thick tree trunk with a kind of naked-looking stump atop. Locally, they call this being 'shrouded'. In late summer, before harvesting, they then have their long shoots spouting up like some unruly hair style! Often they stand in rows alongside the rhynes, from which they draw water to grow, or following ancient roads, marking their way.

Withies – from Old English *withthe*, meaning slender, pliable branch or twig for binding things – are grown as shrubs rather than trees. The osier is the same branch or shoot used in basket-making. These are grown over a three-year cycle (hazel, which has similar uses, has a seven-year cycle). Withy sets are planted in the spring and new shoots grow out of the *stool* that is formed after two years. Harvesting takes place over the autumn and winter, and into April.

It is said that the industry grew up during the Napoleonic Wars, whereas before it was at more of a subsistence level. In 1810, the first withy bed was planted on West Sedgemoor and soon the Victorians were thirsting for wicker furniture in their expanding homes. Like most things, the fashion changed and baskets alone were all the osiers were needed for. When baskets were replaced by imports and then modern materials the bottom fell out of the market, so that by the Second World War few growers were left. Today, although at nothing like the same size, the industry thrives

proportionately to the increasing number of people keen to make baskets on a small scale.

Like turf cutting, withy growing is an arduous task, labour intensive and with many processes from weeding, spraying, cutting, bundling and transporting. It is for this task that the withy boat developed, for often the withy beds on the moors were flooded and the cutters worked knee-deep in water.

The withy boat was flat-bottomed, just as all the boats of the Levels and its inshore coastal waters were. Mostly confined to the rivers Parrett and Tone, they, like the turf boats of the River Brue, were the workhorses of the waterways. They were the mode of transport around the waterways, especially at the time of flood, when some have been quoted as being used to take feed to cattle stranded by waters. Others have been said to have been adapted as duck punts. Built with a flat bottom consisting of several non-edged joined planks of timber, their sides were not as markedly inclined and tended to be at 20 degrees. Again double-ended, the posts raked at different angles, the stem being angled at a slightly higher degree. The bow normally had a false stem and canted knees told which end was which. They were traditionally slab-sided, each side made from two very wide elm planks with a scarf joint in the middle. However, as wide planks disappeared, they became clinker-built with up to four strakes either side. A rubbing strake usually strengthened the gunwales. The bottom was strengthened with floors that were, unlike the turf boats, fixed to the knees; these, like the posts and floors, were of oak. Again, they were tarred inside and out. Lengths were 18–19 feet. Some even had a small thwart.

When loaded with withies, they were usually tracked along the riverbank and sometimes paddled, though outboards were fitted in the latter days of their existence. They tended to be less crude than the turf boats and were kept in the water throughout the year, being pressed into more service than just carrying withies, although their name suggests that was their sole *raison d'etre*. With the decline in the osier industry, their use also decreased so that their existence, apart from a few enthusiasts who retained boats for pleasure purposes, is confined to the few examples in museums and visitor centres.

Returning to the business of osiers, once the withy boat had delivered the withies to the yard, they had to be sorted. Some were boiled for eight hours in the coal-fired boiler to release the tannin. These were then easily stripped of bark and became the buff-coloured rods. Brown rods were steamed for a shorter period and remained unstripped. The best withies were kept back to become the 'whites'. These were soaked in purpose-made shallow ditches (these had to be kept clear of mud to prevent staining) for several months before the bark was stripped off. Stripping was the work of the women and children, who worked by hand with special tools called *brakes*, which were pairs of metal prongs through which the withy was carefully drawn to peel away the skin. The 'browns' were peeled easily because the boiling process softened the skin, which could then be removed with a thumbnail. Any wastage, or even normal rods, went to the charcoal kiln. Here, the withies were cut to lengths of differing thickness before being tightly packed into metal boxes. These were then placed in the kiln and fired at a high temperature. It was important that all the air was excluded otherwise the charcoals burned and could shatter. Once cool, the charcoals were sold to be used by artists throughout the UK. In some cases, they still are.

Although many of the baskets sold in the UK are imported from the East, some are made in Somerset. Generations of basket-makers have developed the skill for which

much of the Somerset withies go. The buff and white rods are soaked overnight to become supple while the brown rods are either steamed for a couple of hours or soaked for five days. Then the withies are interlaced around a framework. The range is wide and includes shopping, display, household, animal and log baskets, chairs, tables and other furniture, trays, hampers, laundry baskets and various fishing artefacts such as baskets for tackle and eel baskets. Withies of a poorer standard, which are not treated in the same way, are used for hurdles, and, on a much larger scale, putts and putchers, which will be discussed in some detail in a later chapter.

What remains of the industry today? No withy boats carry withies, for most of the remaining beds are close to the yards in which they are processed. Derelict chimneys betray the existence of ancient buildings where withies were once boiled and stripped by generations of men and women. Fortunately, however, some growers have survived to satisfy a specialised, albeit shrunken, market for traditionally made British baskets. Machines can strip the bark off, though these are almost as arduous to operate as the older hand-drawing method. Steam rising over sheds divulges modern boilers, whose smell is not particularly appetising. However, the range of baskets seems to be growing even if the prices are somewhat off-putting. With a quality to match the price, though, and centuries of history, it's hard not to buy for there remains something so precious, sentimental even, about having baskets about the house. Is it the notion of being able to touch nature in an almost naked sense, or the pleasing network of coloured rods, or simply the utilitarian nature of them that attracts us? However you look at it, it's a sustainable and natural product for an equally natural lifestyle.

The Willows and Wetlands Centre at Stoke St Gregory has an excellent exhibition about life in the Levels and Moors, including a withy boat. Next door, the Coate family have been growing willow since 1819 and making baskets since 1904. They should know a thing or two about it and here they pass on some of this knowledge. They still grow, harvest and process withies and the resultant basket-work, made by skilled basket-makers, can be purchased in the shop. It really is worth a visit.

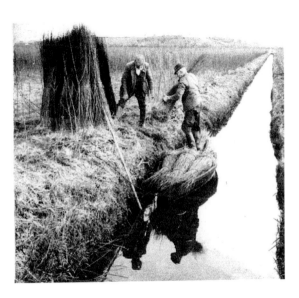

Loading withies onto a small withy boat.

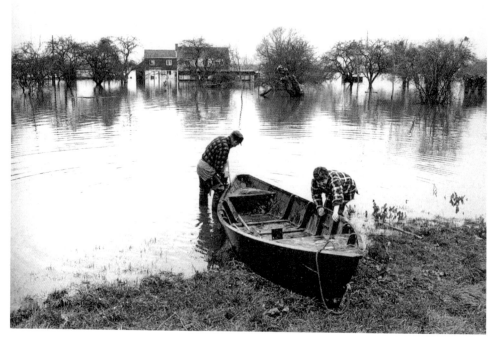

Ex-RN Lt-Col. Billington and his wife at their home, Turkey Cottage, which has been well flooded. Although the boat was borrowed, it is an example of one built from Eric McKee's lines in his book *Working Boats of Britain*. The boat no longer exists and Billington has since built a stank around his home.

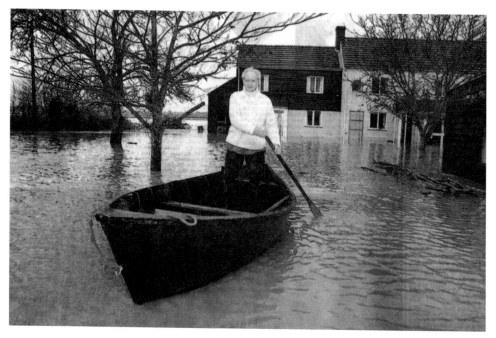

D. Billington again in his borrowed boat.

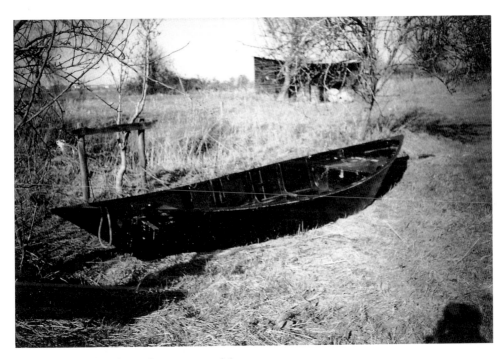

Another view of the boat, this time out of the water.

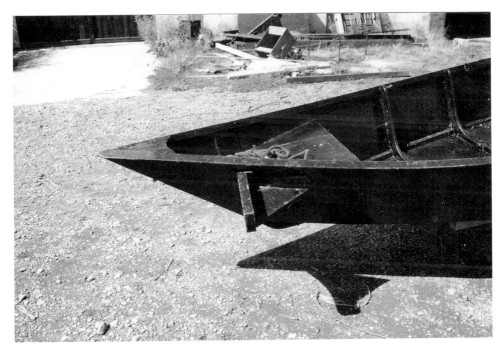

A close-up of the boat, showing the outboard bracket.

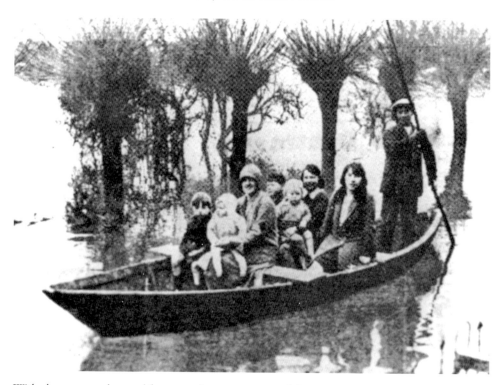

Withy boats were also used for general transport around the waterways. This one is seen ferrying people to Sunday church.

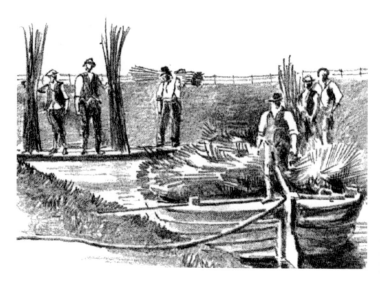

A drawing by an unknown artist of unloading withies into a barge. Though not a withy boat, it illustrates the purpose.

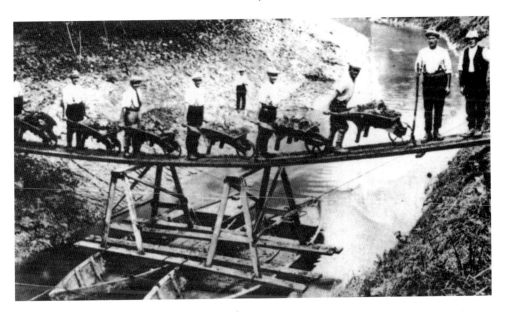

Withy boats being used by the Water Board for temporary supports.

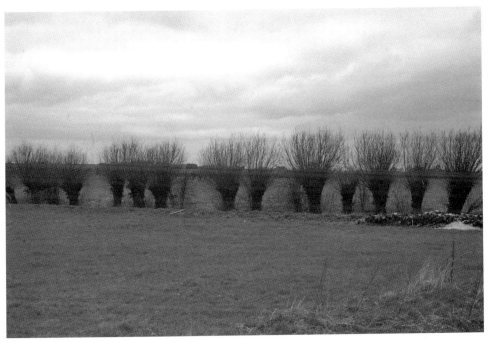

Pollarded trees are often planted to be used as landmarks and waymarks in time of flood. (*Photo by author*)

The boiler for withies at the farm of P. H. Coate & Sons, Stoke Gregory. (*Photo by author*)

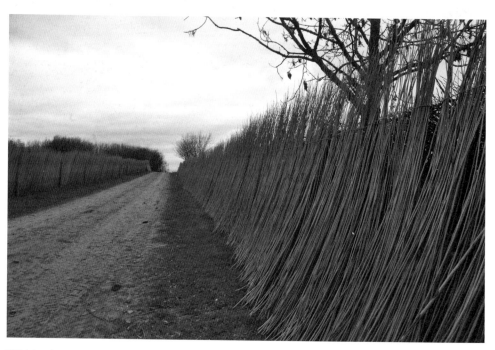

Withies drying at Coate's Farm. (*Photo by author*)

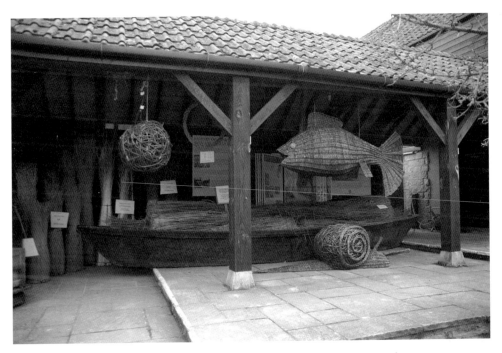

A withy boat on display at The Willows and Wetlands Centre. (*Photo by author*)

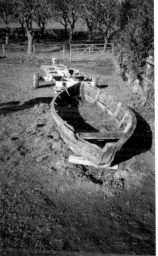

Above left: Mrs Cattle's flatner, used as a feeding trough for her horses.

Above right: The same at the time of its intended removal.

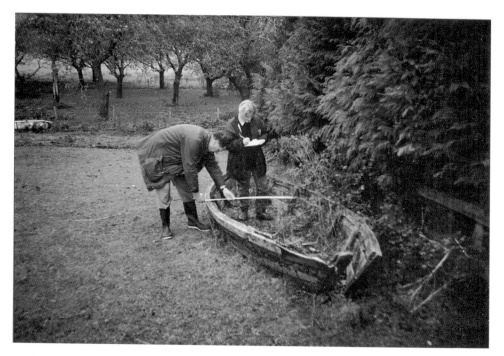

Students from Bristol University began to dig around the boat and unfortunately it started to collapse.

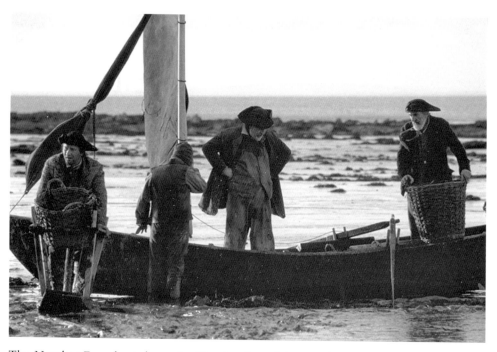

The Number Four boat from the Watchet Boat Museum being used in the filming of *Pandaemonium* in 2001. Some of the actors are recognisable and a temporary rig has been fitted.

Chapter Four

The River Boat

Next in order of sophistication comes the river boat, which is a mature version of the withy boat. As they are almost exclusively confined to the River Parrett they are also known as Parrett flatners, the last word coming from the Somerset slang dialect for 'flat-bottomed one'. This is a term that has stuck over many generations and generally the word 'flatner' describes all the boats of the Somerset Levels.

As a sort of paradox, they are regarded by many as the purest form of the Somerset boat and the one with the most uses, being used to fish, travel about the waterways (even to Sunday School in some cases), carry freight including withies and turf at times, and sail out into the bay to service the fish traps and stake nets. It's a true all-rounder, and part of me wonders why they bothered with the other types at all. However, you might notice that this chapter is the longest in the book, and that's not by chance!

So what is different between these boats and those used generally to carry withies? At first appearance the hulls appear similar, but there it stops. Take a look beneath the water and immediately it is obvious that there is a rockering in the flat bottom from bow to stern as well as a camber across the bottom. The reason behind this was two-fold: firstly, to improve the stability of the vessel in the more exposed and choppy seas of the lower river and sheltered parts of the bay and, secondly, to help prevent the boat sticking to the mud of the riverbank. A boat so built, when rocked by a man moving from front to back in the boat, will come unstuck in all but the thickest, glue-like mud.

The construction was similar once the bottom boards had been shaped. Again, these were non-edged joined and several methods were used to bend the planks. Some covered them with wet sacks and then loaded them up with heavy weights while others simply weighted them with 40-gallon drums filled with water or sacks of stones and left them for long periods of up to a year before carrying on work. That obviously necessitated some advance planning. Once the bottom had been shaped and cut, the sides were fitted at an angle of about 30 degrees, again at first a single wide strake of elm, scarfed just abaft of amidships, until each side was built up in the clinker fashion.

But the main difference, even to the untrained eye, is the rig. Unlike the turf and withy boats, the so-called classic river flatner, as well as having two pairs of thole pins for rowing and a central unattached box or thwarts to sit on, had a short mast and was rigged with a single spritsail and often a small jib. However, as outboard motors developed, many were adapted for this mode of propulsion, with a small wooden

bracket being added or, in some cases, the back end being cut off and a transom built in. In the case of a boat which survives in the Watchet Boat Museum, some three or four feet were cut away before the transom was fitted, giving the boat an unusual tub-like shape for which the boat is now called *The Tub*!

To counteract the rig a daggerboard was also fitted. The rig tended only to be used when sailing out of the river, for the lower part is full of bends, making sailing difficult. Square-shafted oars, rounded towards the loom, were used most of the time, with thole pins instead of rollocks, the former so that if the oarsman caught his oar on the riverbank the thole pin broke and not the oar.

Their use was mainly for fishing. The River Parrett was renowned for its salmon, eels and elvers. Flatners were used to 'pitch' for salmon, a method of fishing, although not practised very much, which was unique; similar methods are used on the River Severn (stop-netting) and River Cleddau (compass-netting) in Pembrokeshire. In this case, the fishermen would moor two flatners alongside each other off the rocks with anchors bow and stern, so that the boats lay across the stream. The net was fixed to a V-shaped affair, about 20 feet across the mouth on 15-foot poles. This was lowered into the water so that the bag of the net trailed beneath both boats and it was held down by the fisherman who stood in the second boat, even though the net was balanced against the gunwale of the first boat. The presence of a fish would be felt through 'feeling strings' which were attached to parts of the net. Fisherman Bob Thorne, well-known in the area, described the way he fished:

What we used to do see, you 'ad your two flatners, used to go out off the rocks on neap tides, 9ft and under, anything over 9ft it'd run too 'ard. 'course on the spring tides, salmon used to go upriver. Right upriver, well they didn't never used to get back. They used to stop upriver 'cos there was plenty of water. Then when as the neap tides do come so the salmon would work back, as water gets scarce and like in the summer very often there wasn't enough water for 'em to go on up in the fresh, see, they'd 'ave to 'ang about river till there was enough water for 'em to go on up fresh, see? Or perhaps for the next spring tide when twas 'igh 'nough for 'em to go on up. Or they used to work back river. Well then what we used to do is on the flood tide to go out Black Rock, put your two boats er you'd have your first boat with two anchors on, one bow, one stern, chuck they out, chuck the two anchors out see, so as you 'ad 'er broadside to the tide. Then you'd come in with your other boat, tie he to'n and put your two dollies, used to have these two sacks with straw in see, put the two dollies one each side the thole pins, you know so she couldn't chaff, see? Well then you had your net which was two long poles, 15' poles and with a 28/30' headline for it. And then, soon as tide turns, 'e'd go out over side of the boat see, and drop down on the bottom because in the river there out on the Rock at low tide there'd be about 2' of water. Well then at the end of th'our on a neap tide you'd 'av p'haps six, seven foot of water. You'd fish for a hour then you'd chuck in because any fish about would be gone on back, see? And that's 'ow we used to do it, see?

The net was out over the first boat, and you was stood in the second boat, like, the boat behind. Then when you did weigh your net down, generally two of 'ee there see, and one, like the one, er, 'ad a axe in 'is 'and so that if anythink went wrong, you

know like the boat started to tip or anything, and you couldn't release the net, 'e'd just chop the anchor line and the boat would swing round, bow on to the tide, see?

Two straight pole with the net in between. Plenty of bosom, see, and the bosom used to go straight back under the boat. Well then you 'ad your finger in the mesh, see, and soon's you felt a tug you knew something 'ad gone in the net. Well sometimes 'twould be a flatfish, could be a big eel, anything. But you know like I've gone out there there or four days with th'uncle and 'ad and 'ad a fish or nothing. 'ad one or two flatfish and that, nothing. Then all of a sudden you go out there, catch the right tide when the fish 'ave gone back down and 'ave perhaps two or three fish there, in thick hour, see? That's 'ow it used to work.

There were once some twenty licences issued to permit fishing in the river, though catches declined after the 1930s, due partly to pollution.

Dip nets were also used from a flatner to catch salmon as they swam upriver with the incoming tide on the Parrett. Each net was licenced and the licence number had to be displayed upon the net. The fisherman rowed with the tide and noted the spot where the fish came up to clear his gills. The Parrett was, still is, a very muddy river, and the salmon couldn't travel more than about 25 yards without clearing. Having noted the spot, he let his oars go to be caught in the thole pins, ran to the bows of his flatner, and dipped the fish next time it appeared. The fish was killed with a bash on the head from a 'priest' or 'killing stick'. It sounds easy, and has been described as a 'sport' but it was in fact hard work, and a keen sense of balance was required. Some of the boats used for this type of fishing were not fitted with thwarts, but had a central box which served as a rowing thwart and storage. The obvious advantage is a clear run forward. The traditional pattern of dip net was like a large Y with a six-foot headline (the legal maximum) and a long handle. A more conventional net superseded these cumbersome nets, rather like an overgrown butterfly net, some time after 1945. They only survived that long as Somerset fishermen were, by nature, very conservative. 'If 'twas good enough for father, 'tis good enough for me' was their attitude, similar to that of many other fishing communities. This method of fishing still survives on a very limited scale, in spite of the high cost of the licence. The nets are similar to the lave nets used on the other side of the Bristol Channel, but there the fishermen stand in the water rather than in a boat. The subject of dip nets cannot pass without mentioning Salmon Parade in Bridgwater, where salmon were often regularly caught from the pavement as they came upriver – except on Sundays, when it was illegal. Dipping was confined to the lower River Parrett, between Dunball and Bridgwater.

Eels were caught in fyke nets, in withy or wire traps, by spearing and by an unusual method called 'clodding', sometimes known as 'ray-balling'. Elvers – deemed a delicacy at Easter time, when they were fried with bacon fat and the odd rasher – were caught in an elver net, a sort of scoop net. Although none really necessitated the use of a flatner, all are worthy of a mention.

Fyke nets are set upon the riverbed. They consist of a long wing to direct the fish into the net, which is a series of funnel-shaped meshes ending in a cod end. These nets do not work well on fast flowing rivers, though they do work in the rhynes and slow-running waterways up river.

Traps, after being baited with offal, are simply placed on the riverbed and the eels swim in during their search for food. Again, they do not work well on fast-flowing rivers.

Spearing with a flat-sided five-barb spear can take place from a small punt – or turf or withy boat – in the upper reaches of the Parrett but only works in clear water, which is rare these days. The last spears in use legally were back in the 1930s.

Clodding, or ray-balling, is done by threading large worms onto a length of worsted, which is then formed into a ball. This is tied to a piece of strong line and attached to a long hazel rod. The worms are dangled into the river and when an eel bites, because his teeth grow inwards, he becomes stuck for a short time to the worsted. Thus the rod and line with eel attached is swung onto the bank, into a net or even a boat. Warm, moonlit nights are best and often a boat moored mid-stream is used. Some work from the bank and swing their catch into an upturned umbrella.

Elver fishing also took place from the riverbank with scoop nets. These were 3 feet long and 2 feet wide by about 20 inches deep, built on a wooden cradle attached to a long pole. The frame was covered in muslin or cheesecloth and was dipped to scoop the elvers out. It had to be used very gently in the water otherwise any movement was detected by the elvers. However, elvers were over-fished several years ago when their export to Japan raised such a huge price that everybody who could was out fishing. The stocks disappeared as outsiders arrived, to the annoyance of the locals. Permission from landowners to fish the best spots was ignored, arguments ensued, violence followed threats and before long the elver had vanished. Human greed never changes and the over-fishing of all sorts of species around the world is a never ending result of similar gluttony.

Dip-nets cannot be adapted in any way, according to the Environment Agency regulations. No floats, ropes, stakes or anchors can be used and they must be operated by hand. However, illegal fishing has been a problem, especially when elvers fetched £600 a kilo in 1995. Although there are 150 licences on the River Parrett, over a three-year period 150 illegal nets were seized, which led to 1.5 tons of aluminium being recycled. Ten fishermen were banned over the same period and two vehicles were seized. These nets were largely aluminium-framed flow nets which can have a rectangular mouth of 10 by 3 feet. The net itself can taper over a length of 30 feet to the cod end and the bailiffs are constantly on the lookout for them.

A good example of this was when two Bridgwater men were banned from fishing for elvers for three years for using an illegal flow net to boost their catch. They were also ordered to pay £1,860 each in fines and costs and had their equipment confiscated. The case was brought by the Environment Agency after their bailiffs were on a routine patrol near the Westonzoyland Pumping Station on the River Parrett on May 14, 2010 when they discovered a large flow net, two aluminium poles and a length of blue rope hidden in undergrowth on a flood defence bank.

Returning later in the day, the bailiffs kept the river under observation, using a camera to record illegal activity. At 7.00 p.m. two men appeared. One of them walked towards the net while the other climbed to the top of the flood bank to keep a look-out. The pair were then seen positioning the net in the river before walking away.

Later that evening the fishermen returned to retrieve the net, carrying a bucket. Both men tried to run away when they realised they had been spotted by bailiffs. They were apprehended and the net recovered. When questioned, the men said they had used an illegal net because they were 'cheesed off' that other people were using flow nets on the River Parrett to boost catches.

Over-sized nets give fishermen an unfair advantage over their law-abiding competitors, who are only allowed to fish for elvers using dip nets. These must be operated by hand and not fixed to the riverbank in any way. Tethered to the bank by strong ropes, flow nets are highly efficient and less selective than dip nets. Elvers and other fish are funnelled into one small end, where they can be easily removed. Some are crushed and die when caught in this way.

The net seized by bailiffs at Westonzoyland was three metres deep and had an opening approximately twice the maximum legal size. It contained around 100 grams of elvers, which were returned to the river. Elvers attract high prices and were fetching around £250 a kilo at the time.

The number of young eels migrating into our rivers has crashed in recent years and the eel is now listed as an endangered species. It is estimated that there has been a 70 per cent reduction in England and Wales and 95 per cent over Europe as a whole. The use of illegal nets to increase catches is unsustainable and threatens the survival of the eel. A kilo of elvers contains approximately 3,500 young eels. Not surprising, then, that the stocks were so decimated.

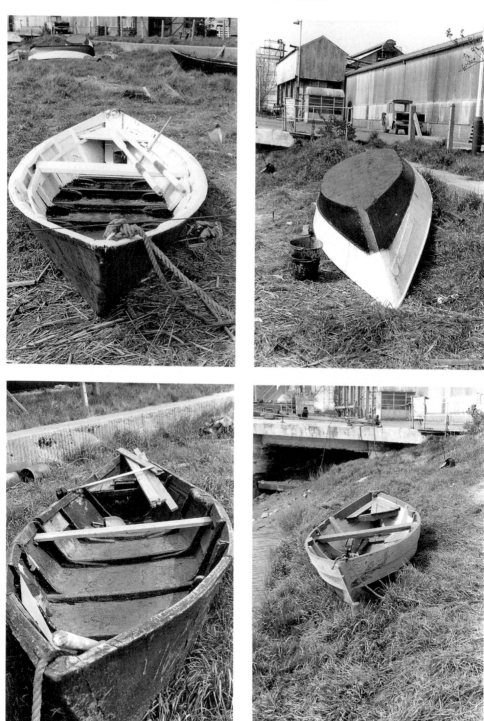

These pages: A series of photographs taken at Dunball in April 1968. These show various flatners along the riverbank, though only two appear to be in use.

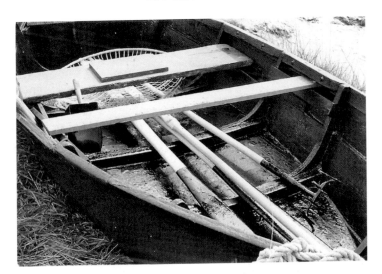

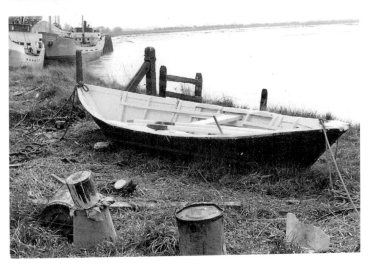

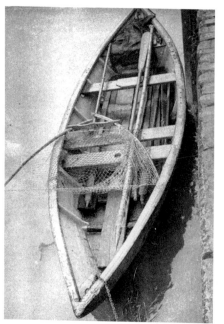 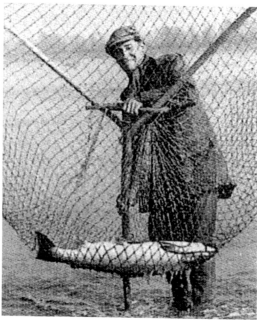

Avove left: A River Parrett flatner at Bridgwater equipped for fishing with a dip net.

Above right: A successful catch in a lave net. Although similar to the Somerset dip net, the lave net was used by fishermen from the River Severn.

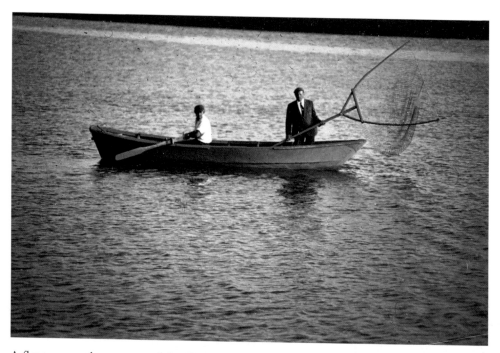

A flatner, now the property of the NMM, in the river with dip net at the ready – although this appears to be a posed picture for the camera only.

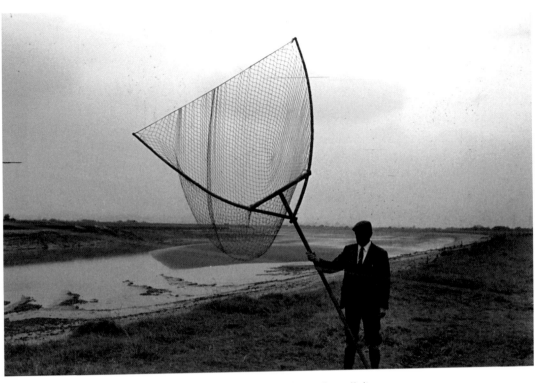

Above and below: Another two posed photos with big and small dip net.

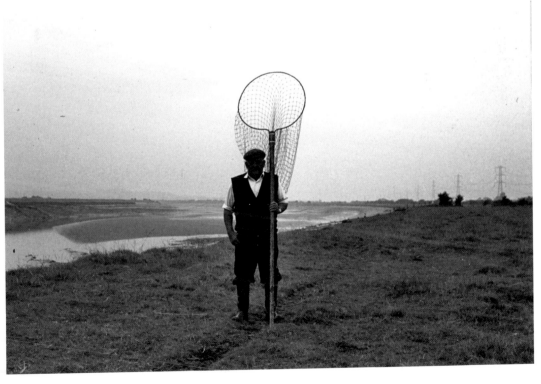

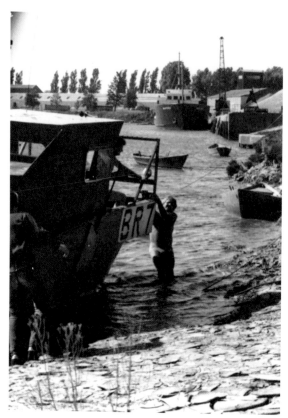

Dunball wharf, with a certain amount of wading in the mud. Of interest are the two flatners moored in the river behind, obviously still working and probably owned by one of several people working at the wharf who also fished.

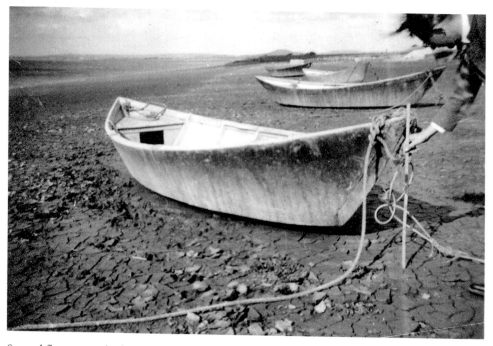

Several flatners on the foreshore near Dunball.

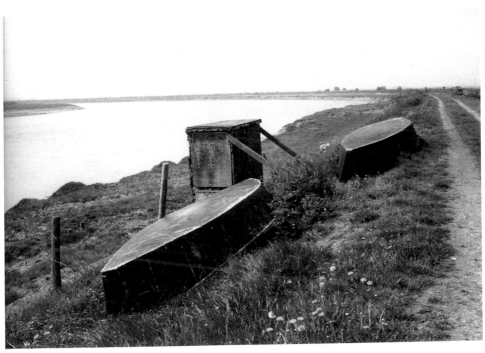

Dunball flatners again. These two were built by Les Pople in 1968 and one of them passed into the ownership of the Watchet Boat Museum as Number Four boat. They are strengthened with fibreglass and are considered examples of modern flatners.

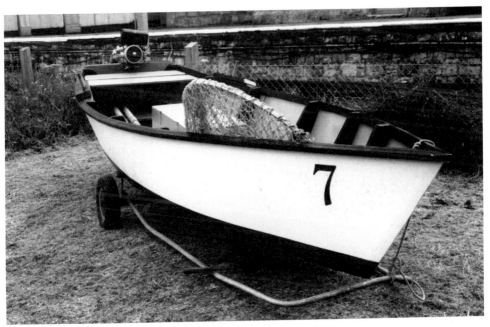

The Number Seven boat in the Museum's collection is thought to date from the 1920s, although the transom was added at a later date.

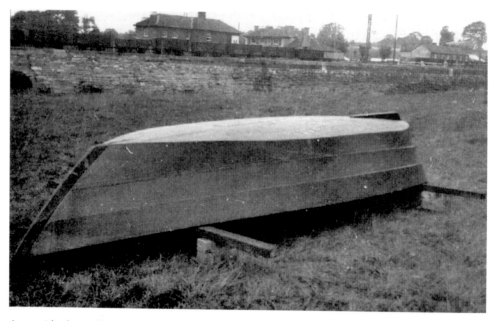

An upside-down flatner showing the flat-bottom and the small skeg which was added to some vessels.

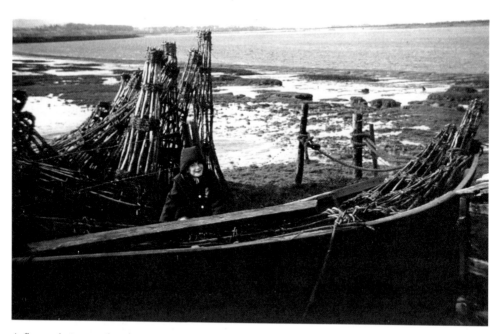

A flatner being used to transport putchers out to one of the ranks in the River Parrett.

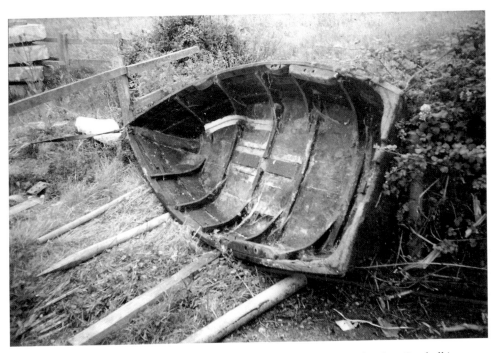

Above and below: Two views of 'The Tub' as it was found by the river bank at Dunball in 1999. This is said to be typical of the river flatner.

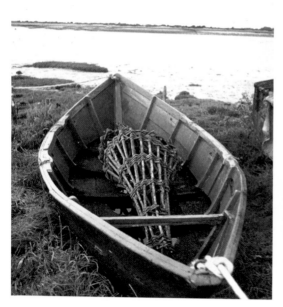

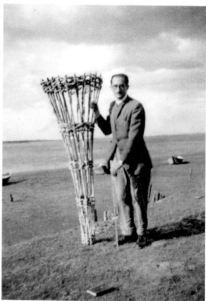

Above left: One of Bob Thorne's flatners at his fish shed near Black Rock.

Above right: A photo demonstrating a putcher, taken by Dr Chapman.

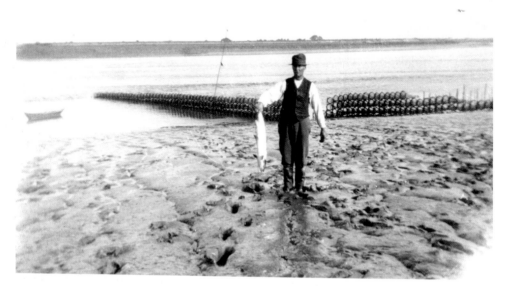

A sea trout taken from one of the ranks of putchers on the River Parrett.

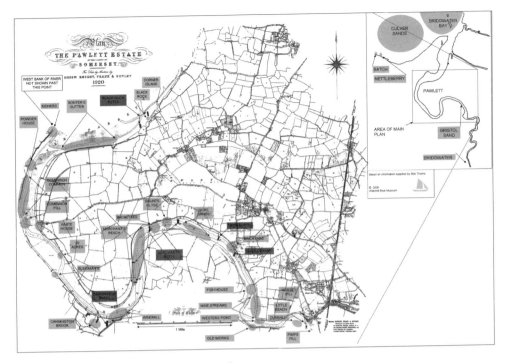

A map of the fishing stations on the River Parrett.

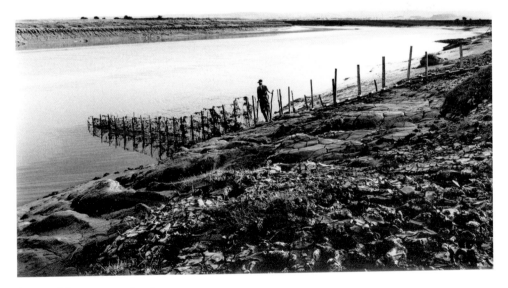

A peaceful scene over the river.

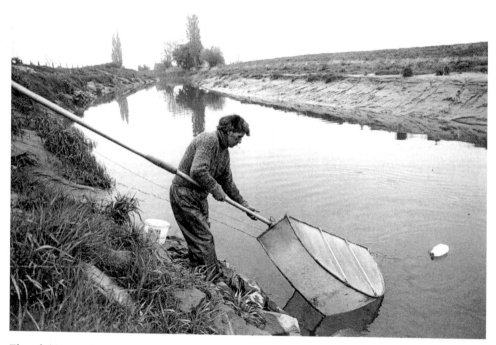

Elver fishing in the River Parrett. Until recent price rises the eel population was constant, though this changed as exports created a rush for elvers.

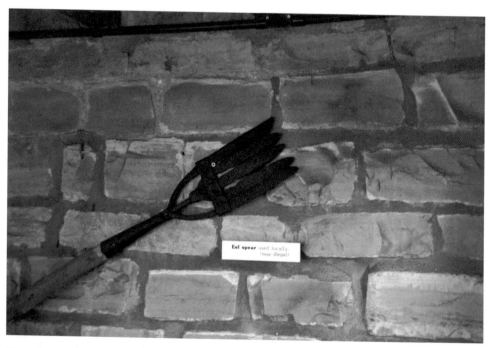

The eel spear was a traditional way of catching eels. (*Photo by author*)

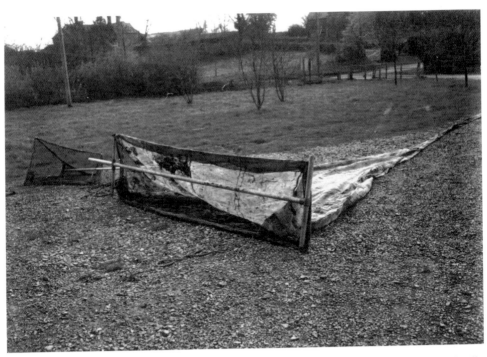

Demonstrating the flow net. Although illegal to use, it can be seen just from its size how deadly it could be.

The smoking chamber for, among other fish, eels at the Brown & Forrest smokery between Curry Rival and Hambridge, which produces one of the best smoked eels around. (*Photo by author*)

Chapter Five

The Sea or Gore Boat

Salmon fishing in the Bristol Channel is one of the oldest surviving industries and was for many years an important contribution to local economies. Overfishing in the Atlantic has now all but killed off this ancient industry. Now, most of the boats, tools and methods associated with the fishing are almost extinct.

The oldest method of salmon fishing was by fish weirs, otherwise known as 'fixed engines'. These certainly date back to medieval times, and possibly even earlier. Weirs are known to have been in use at Carhampton in 1606, Watchet in 1614, Minehead in 1621, Stockland Gaunt in 1682, Stolford in 1769 and Black Rock in 1797. Many of the sites are still shown on current OS maps. Weirs are low, V-shaped walls of loose stones pointing seawards, raised up by oak posts between which withies were woven to create a wall through which water could flow but fish could not swim. Often, the point of the V would have a net across it instead of a continuous stone wall and any fish not quick enough on the ebb tide would be stranded. Weirs went out of fashion with the introduction of stake nets, although they still exist at Minehead, where they have been scheduled as Ancient Monuments. They were in use without their withy fences up to the late 1980s.

Stake nets are set out just above the low water mark and consist of a row of wooden stakes about six feet apart with the nets hung between them. Better catches are obtained by putting the nets below low water and then weighing the nets down with iron rings or loops of suitable chain, but this requires the use of a boat, both for driving in the stakes and picking up the nets to check the catch. The type of catch in the former category depends on the type of net, for some have straight drops of netting while others have shrimp nets which hang like an open mouth and lead to a small cod end which is staked to the shore.

Thus developed the sea, or Gore, boat. These have also been referred to as Burnham boats, and as bay boats. With the Gore sands being six miles out into the Bristol Channel, the boats would sail out past Burnham on the ebb and return on the flood. Some were fitted with washboards so that the freeboard was raised when loaded with fish, especially sprats. The catch would normally be landed at Burnham jetty or Combwich, though sometimes they would even sail up to Bridgwater to sell at the market there. These flatners were on average between 17 and 20 feet in length and differed only in that they appeared to be slightly stronger in build than the river boats to cope with the extra stresses of sailing in the Bristol Channel, where the tidal range is

the second largest in the world. They too were rigged with a spritsail and jib and most had five planks in the rockered bottom. These were the boats said to have sailed across to South Wales to collect coal or the odd sheep.

The sails were traditionally made from cotton, though locally grown flax cloth was probably used before cotton was available. Cotton sails, however, rot easily in the maritime environment, where the damp and salt attack them. To counter this, the fishermen would immerse them in a solution of oak bark and water in which the tannin helped to seal the fibres. The added bonus was that this coloured the sails a tan colour, hence the term 'tanning the sails'. When cotton sails became common, cutch was used instead of oak bark. This, otherwise known as 'catechu', comes from the Indian Acacia tree and was imported from the subcontinent in a solid form, a bit like treacle toffee, in wooden boxes. It was added to boiling water in big tubs, where it melted to form a brown or reddish colour, sometimes with the addition of colouring. This was brushed onto sails. Nets were also treated with cutch to prevent rotting in the sea by immersion in the liquid, a process known as 'barking'. Cotton sails were superseded by man-made materials, terylene to begin with, and then the more manageable Clipper Canvas and Duradon in recent years.

In Watchet the boats were known as *flatties*, the only difference being that the bottom had an extra layer of planking, as they were constantly launched down the rocky foreshores of the area. They were strong craft, weighing at least a ton, able to cope with much of the seas thrown at them about the Bristol Channel. In relatively recent times, many of these were built at Combwich on the west bank of the River Parrett, said by Tony James to be the stronghold of the flatner and, by some, the place the best boats were built. Before that, many were built at Watchet. Most of these serviced underwater stake nets, although they also fished for herring, mackerel and sprats in the same way as the sea boats did.

The 'Hang' was a large (200 yards long) type of stake net very close to the mouth of the River Parrett which is marked on maps dating back to 1800 but is deemed much older, though it has not been used for many years. Here, in more recent times, were stake nets belonging to Bob Thorne. Putchers and butts were also constructed here. These are conical-shaped baskets made from willow, though butts were the much larger of the two. They consist of three separate sections – kype, butt and forewheel – which, when fixed together, meant that a butt was up to fifteen feet in length. The kype was the mouth, with an opening six feet in diameter, while the smaller forewheel was where the fish became trapped as it swam in. Although extinct these days, several would be placed on the foreshore alongside each other, though during the off-season the mouth of the butt had to be closed off.

Putchers, still in use in a few places on the River Severn, were much smaller baskets, some five or six feet long, which were arranged in ranks, up to six putchers high and many alongside. Bob Thorne's, which were at Black Rock inside the River Parrett, were only two high. Putchers have to be taken ashore during the closed season, whereas the butts must be closed off to prevent fish entering. It is said that before 1866 there were over 11,000 putchers on the River Severn alone, with hundreds more on the other rivers flowing into the Bristol Channel such as the Parrett. Occasionally, Bob Thorne would have to take his flatner out to service his baskets.

Shrimps thrived on the sandbanks of Bridgwater Bay and these are caught in the stake nets, sometimes referred to as bag-nets. The only trouble with these nets is that they tend to catch lots of immature fry. In 1872, according to Holdsworth, there were sixty-nine second-class and twenty-five third-class boats working out of Bridgwater, all of which worked both for fish and shrimps. These he called Burnham boats though, from his picture, they were obviously Bridgwater flatners.

Skimming is another way of catching shrimps, for which a flatner was used to take the fisherman out to the Gore sands. John Nash described it to me:

> A skimming net consists of two 15ft square poles tapering from two inches to one and a half, joined at 15 inches from the thick end with a bolt through so that they open like a pair of scissors with a 12-foot headline. On the other ends there are the convex end of a small camping-gaz bottle that acts as a skid and if not two old wellies are used. Thus the net is skimmed along the sand as it picks up everything in three inches of water, catching shrimps and flounders mostly. Hard work for very little reward but these fishermen never missed a chance to catch fish.

In the previous chapter we discussed eel catching. On the Somerset coast, principally at Kilve, conger eels are caught without a boat, but with the help of a small dog. This is the sport of 'glatting', where the dog in question has to have a nose for congers and for which the fisherman must have a 'glatstick' (a pole of hazel or similar) in which to poke about the rocks and a good pair of wellies. The dog does most of the work in spotting and extracting the conger with his teeth, just helped along by a bit of poking with the glatstick. Further along the coast, at Stolford, the Sellick family are the last of the mud-horse fishers, a method described in my previous book, *Fishing Around the Bristol Channel* (Stroud, 2011).

Finally, the similarity of the flatners to some river and estuarine craft in Ireland is worthy of a mention. The cots of the south-east part, around Wexford and the River Suir, are perhaps the closest in likeness, although there are certain similarities in the 'gandelows' of the River Shannon. Both also have their upriver versions and larger estuarine craft, though in the latter case these were generally known as 'gangloes', of which no examples have survived.

The word 'cot' comes from the Irish *coite*, which means a log boat. Today's cots, though, are not log boats, although the suggestion is that they developed from such craft. Whether these log boats then became 'extended' by the addition of planking – craft like this are still in use in many parts of the world today – and then fully planked craft is not known, and never will be, but it is probable. This is another reason, then, to suggest that flatners evolved the same way. What is also quite likely is that they are a combination of two influences upon boatbuilding techniques that have come about over a couple of millennia, these being a southern influence from the Roman times in Britain and a more recent – by comparison – influence from the northern Vikings. This is because they have a flat bottom consisting of planks of timber butted together – similar in a way to the craft of the Veneti tribe of northern France, as described by Julius Caesar, yet their upper planks are clench or clinker-built in the same way as the Vikings constructed their craft. In other words, a hybrid of building techniques resulting in a strong, yet easily built vessel. More reasons, then!

A few years ago I met Jim Devine, who lived adjacent to the River Suir, a few miles upstream from Wexford. He showed me his shed, where a cot he'd recently built lay. He described the method of building in a brief and simple way. So much of what he said reflected what I'd heard about the building of flatners.

'It's all white deal to the water except the garboard, which is marine ply. That wouldn't have been the case before but because it tends to rot first it's easier to replace. I set up the bottom first, four planks as you can see, shaped and two inches thick. Then you have to get the rocker by weighting the middle of the bottom. I use these weights here. Do you recognise them?' he said, pointing to lumps of iron. They were railway chairs, which the railways used to sit in during the days of wooden sleepers. I nodded the affirmative.

CIE, the [Irish] national railways, they were throwing them out. I put them in the middle and jack up either ends to give a five-inch rocker. That's enough on an 18-foot boat. They used to be longer – 23½ feet until Pat Savage introduced the smaller boat about 25 years ago – then the boards are nailed together through the floors. Elm or oak there. The stem is notched on and the sternpost just sits on the bottom with the small transom fixed. Then the planking can be added using three moulds, these planks tapering progressively more and more so that the third plank is tapered a lot more than the first. The knees are grown oak normally if I can get it, or sometimes sawn elm. The rubbing strake, two by one inches, adds an enormous amount of strength to the gunwale. As you can see the floors and the ribs are alternate. Add a few thwarts, strengthen around the rowlocks and that's it!

After chatting some more about the boat, he took me down to the bottom of the field where several cots lay in the grass.

'With the salmon fishing gone some folk aren't going to the water this year [2007]. That one there is 35 years old.' He pointed to a grey one with a wide transom. Alongside was another green-painted one with a wooden bracket at the end to take an outboard.

'That one's longer, see, that old one.'

It certainly was, and more solidly built: thicker planking but much heavier. I asked what fishing they did.

The salmon was the best though the licence was a lot of money. €190 last year and €380 this year though we didn't have to pay with there being no fishing. There were 75 licences though some now handed in. Three years ago this river was one of the best salmon rivers in the country but not a lot here last year. Too much drift-netting out at sea. They're still drifting in Kerry, though. There's hope it will come back here in a few years. Used to go and fish the herring in Wexford Harbour outside the bridge. Some used a ring-net. A few wildfowlers still use cots.

We walked down to the river as he explained the salmon fishing in more detail. Much of what he said sounded as if he was talking about salmon fishing in the Bristol Channel. Several cots were moored off and a couple sat on the river bank. He showed me the remains of a very old one that was almost rotted away.

'See how big she was. Look over the other side, can you see those moored there. They belong to wildfowlers.' They were so low in the water that they were difficult to see, as if hidden from anyone, about to disappear. Five years later, I was reminded of these as I studied dozens of photographs of flatners and turf boats, flatties and withy boats. The trouble was, these had disappeared and would not return.

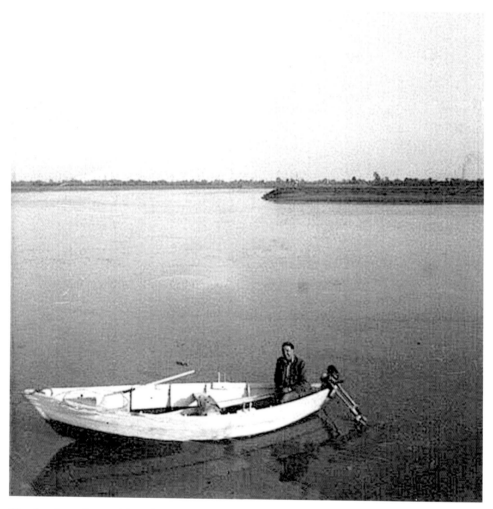

Number Seven boat with outboard before the stern was cut off.

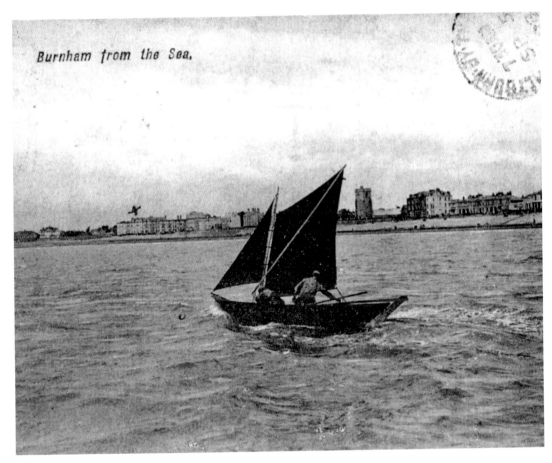

Burnham from the Sea.

A postcard view of a flatner sailing past Burnham-on-Sea

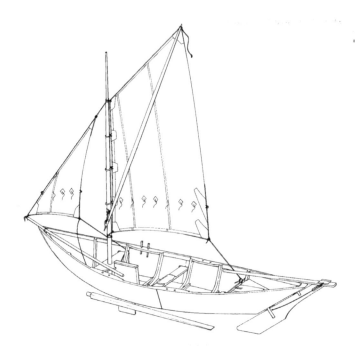

The well-known drawing of a flatner by Eric McKee. (*Courtesy of Mrs Betty McKee*)

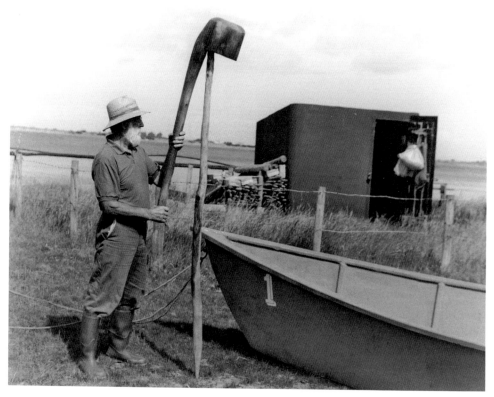

Bob Thorne demonstrating the use of a maul to hammer home a post for a stake net.

Here he is using a maul in the field, helped along by his nephew.

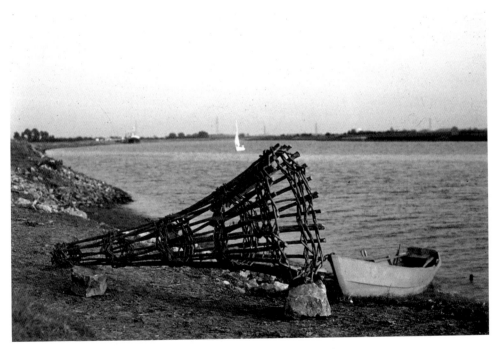

A butt and a flatner alongside the River Parrett, obviously posed.

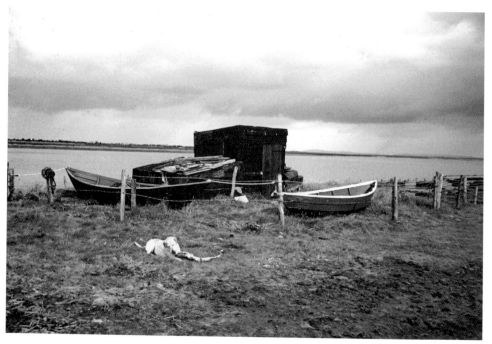

Bob Thorne's fish shed.

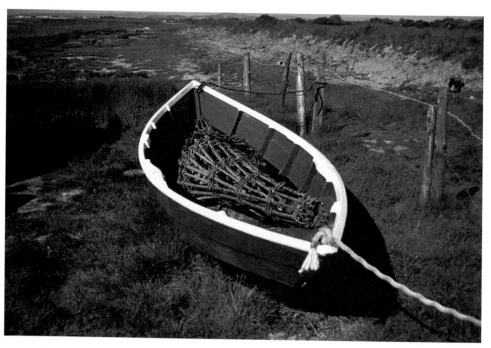

One of Bob Thorne's flatners outside his fish shed, this one becoming Number One boat.

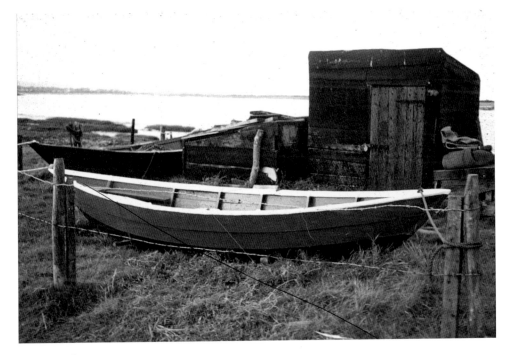

The same flatner.

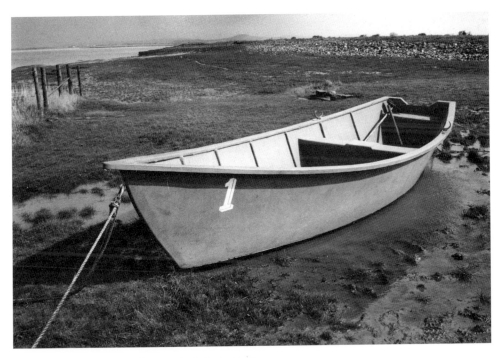

Bob Thorne's fibreglass flatner, which he built about twenty years ago.

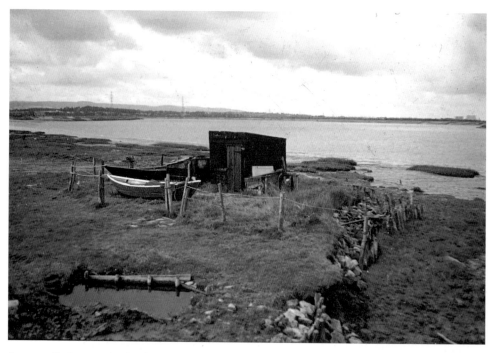

An overall picture of Bob's fish shed, showing its exposed position, away from any civilisation.

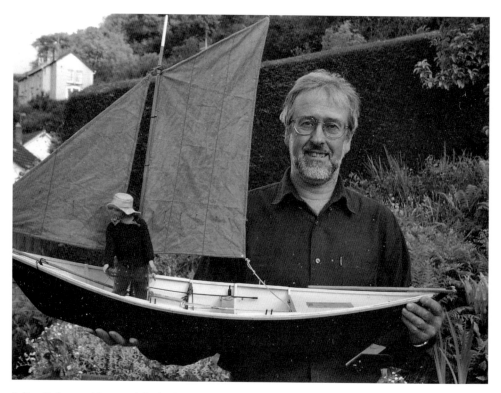

Julian Palmer with a model of a flatner he built.

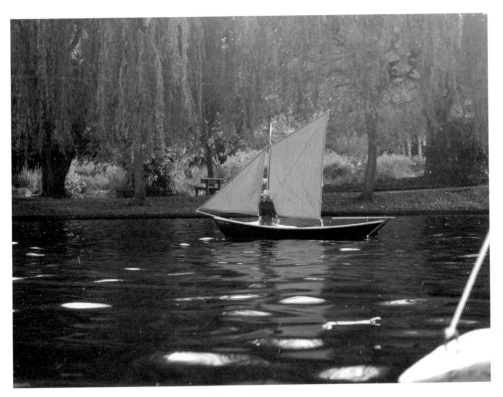

The same model being sailed around a lake near his home.

Kim's Boat inside the Watchet Boat Museum.

Detail from Number One boat showing its red painted oars, dip net, priest, bailer and thwarts. The red paint was matched to imitate red lead, which the fishermen used. (*Photo by author*)

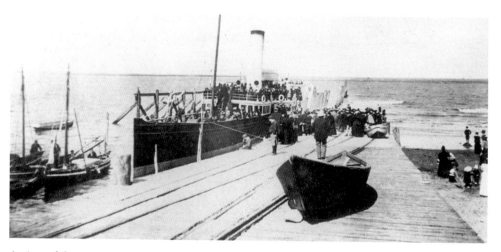

A view of the quay at Weston-super-Mare with the steamer *Waverley* alongside. A River Parrett flatner sits upon the quay while a Weston flatner appears to be further down the quay.

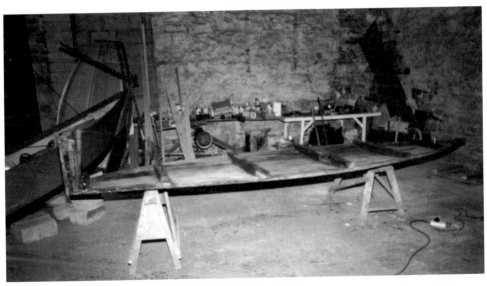

The base of Number Seven boat in the cargo shed before it became the home of the Watchet Boat Museum. The boat was stripped down for rebuilding in 1997.

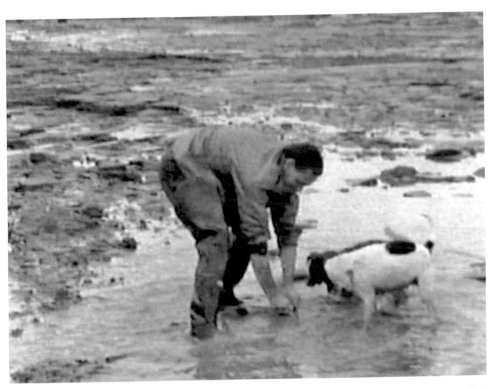

Glatting with dogs at Kilve. A glatting stick is used to poke the conger eels, which are then pulled out by the dog. Congers have a strong grip and one story tells of a man whose hand was stuck in the mouth of a conger which refused to let go. When the tide came in (and it comes in quickly), he had to cut his own hand off. The story continues that he went to the local blacksmith and put his stump into molten tar. Ouch!

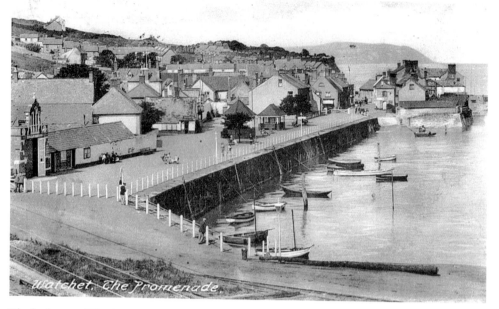

The harbour at Watchet with a couple of flatties.

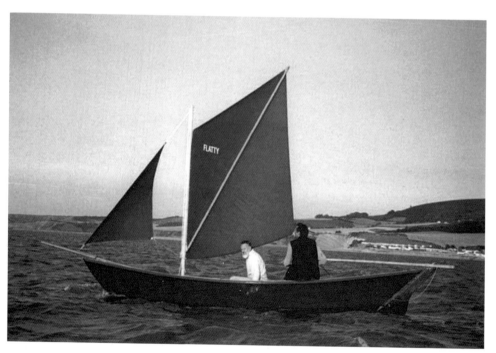

Yankee Jack sailing

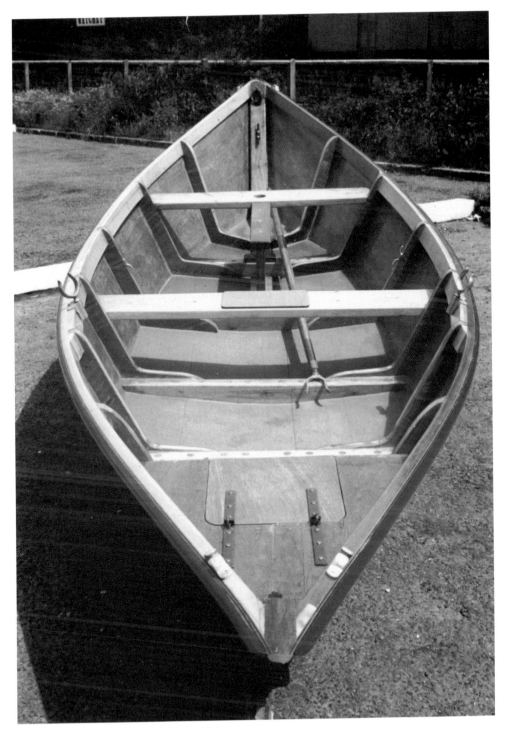

An internal view of Tony James' flattie *Yankee Jack*.

Chapter Six

The Weston-super-Mare and Clevedon Boats

Weston and Clevedon, further up channel, had their own flatners, though they were of a totally different design and construction, the only similarity being that they were flat-bottomed.

These boats – *flatners* and not *flatties*, mind – were more of an offshore boat. Weston was a flourishing fishing village back before the Victorians transformed it into an equally flourishing seaside resort with its well-known piers. The first pier, at Birnbeck Island, was where they dried their nets and close by, on the northern foreshore, was what was once known as 'Sprat Beach', for here were the stake nets – or 'stalls', as they called them – that the fish were caught in. More stalls were around the point in Sand Bay. The first documented reference to fishing dates from 1492, though little else surfaces until the early nineteenth century when, according to Brian Waters, this fishery was worth £10,000 to the town and it was followed through the autumn, from October to Christmas. A ton of sprats was taken to the market in Taunton in a single day. Much of the catch was smoked locally in cottage chimneys and the first basket of the year always went to the lord of the manor, who owned the fishing rights. He also got the first salmon of the year. Waters adds that a particular quaint feature of the Weston sprat season was the job of 'gull yellers'. Two men were thus employed to use whatever means, including, as the job description suggests, yelling at the seabirds, to keep them away from the nets as the tide ebbed and before the fishermen were able to empty them. After the sprat season was over, the herring came inshore and a substantial amount was also caught in late autumn. They also fished out into the bay, lining and trawling.

The fishermen's boats were about the same length in general – around 20 feet – though it is said that a few were built towards the 30-foot mark and there have been reports of some as small as 10 feet. Most appeared to have been transom-sterned, unlike the double-ended Parrett flatners and Watchet flatties (even if they were the same thing), and were good sailing craft. Rigged with one sprit sail normally, they ran out to Flat Holm and Steep Holm fishing for sprats, herring, sometimes shrimp and salmon and haddock during the summer season.

As tourism developed in Weston after the physicians of Bath sent their patients here to benefit from the sea air and water – and later to nearby Clevedon – the flatners grew a little in size. This was to accommodate trippers who took the chance for a short voyage around the locality, the fishermen finding this source of income more profitable

during the summer months than fishing, as long as it did not interrupt the sprat season. Some of the bigger vessels had two masts, which, by coincidence, was how the first written description of being aboard one appeared. This was in 1831, in an account of a trip to Steep Holm by Thomas Clarke. The small Steep Holm was where a group of Viking/Danish raiders were driven after an unsuccessful raid upon Watchet in 914, though they came back again. In 1776, a refuge hut was built there for the use and safety of any fisherman having the misfortune of finding himself there. In this report, the party sailed in a 27-foot boat with two masts and sails, although it was said that the boatman had to row the whole way because of the lack of any wind!

However, a couple of years before, in 1829, there was an entry in *Rutter's Westonian Guide*:

> The Weston pleasure and fishing boats are well built and of a good class. They are accounted to be good sea boats of a sufficient size comfortably to accommodate a considerable number of persons, but mostly without deck. They are manned by careful and experienced boatmen, who are remarkably civil and attentive and who generally charge 10s. 6d. for a day's sail, for a party, or 1s. each. The usual place for embarking is at the small pier at Knightstone, but the shore is so flat that the tide rapidly retreats from this spot. At the Anchor Head slip parties may embark or land three hours earlier than at Knightstone.

The design of these boats is deemed to have been influenced by the traditions of fishing so that it seems likely that they were a development of the flatner. They were cheap and simple to build, shallow in draft for the local conditions and good sea boats.

Bye-laws were introduced in 1869 to regulate the hiring out business. There were two classes – sailing boats as class one and the rowing boats, usually without sail, as class two. Most are assumed to have been flatners. Interestingly, among all the new regulations were the following: three oars were to be carried, and three thole pins per rowlock. A bailer must also be carried and the typical bailer used was very similar to that used upon the Bridgwater barges.

By *c.* 1900 there were still about ten flatners working. They were either single or double thickness in the bottom, which was rockered and cambered like the flatners. The sides were clinker, on average seven planks, which met at raked ends, though some had transom sterns. Originally sprit-rigged with a daggerboard, the two-masters usually had a small lug mizzen, though many changed to gaff rig in the early twentieth century. By the 1930s some were being fitted with inboard engines, though these were only used for pleasure. Harold Kimber of Highbridge built a few of these, including *Flare*, *Patricia* and *Jenny*. Weston's fishing traditions were well out the door by then and numbers quickly declined as tourism also followed a downward spiral. Although Clevedon followed a similar pattern to Weston in terms of fortunes, its boats tended to be smaller at around 16–18 feet. One such example was the 16-foot *Jenny*, which was built around the late 1940s and subsequently converted into a yacht and renamed *Lisa*.

It's interesting to note that the sea-going Wexford cots, a larger and more substantial cot which is related to the River Suir cots, as described in the previous chapter, are

indeed somewhat similar to these larger, sea-going flatners. It would appear that the larger-sized craft of both types – flatner and cot – developed in the same way. Whether influence came from one to the other is not clear but with Bridgwater vessels trading across the St George's Channel to Wexford, it is surely distinctly possible, if not probable, and not merely coincidence. It could also be argued that this was an obvious evolution of the smaller craft and, as such, was a natural development in both areas though, with no other examples in European waters, this would seem slightly superficial.

Only a few Weston flatners exist today; *Flare* is one, now in the Weston Museum as a static exhibit. She was built by Harold Kimber in 1963 for Alf 'Juicy' Payne, who was the longest serving coxswain of the Weston lifeboat. This was to replace his earlier boat, *Surprise*, which was wrecked by the 'carelessness of those hiring her'. At 22 feet in length, *Flare* had a motor fitted from the outset and never had sails. When Alf Payne died in 1984, the boat was bought by the museum from his son Derek and was considered to be the last Weston flatner. However, they were wrong about that because another, the 19-foot *Patricia*, languishes in the collection of the World of Boats at Eyemouth.

Furthermore, the oldest still in existence is the 1936-built *Ann*, which is currently under restoration in Watchet. The 23-foot boat was built by Frank Webb, who was a Weston boatbuilder who seems to have been well-respected. He appears to have been a fisherman and boatman as he owned the flatner *Empress*, which was built by John Watts, who also built the *Silver Spray* in 1903, and which was measured and drawn by Eric McKee in 1969. However, Frank Webb also built the *Pride of the West*, the *Marie* and the *Surprise*, so we can assume him to have been an accomplished boatbuilder. He had premises in Osborne Road and continued working up until the 1960s. Dick Chapman was another boatbuilder with his own yard in Swiss Road. Others were built at Uphill.

According to Eric McKee, the builders shared the three moulds used. They were started upside down by bending the bottom elm planks over the moulds and stem and sternpost. The bottoms consisted of two or three planks. When the garboards had been fitted onto this, another layer on the bottom was normally added in the same way as the Watchet boats had. The boat could then be turned over and the sides would be built up in the normal way for a clinker vessel. In the early days, sawn frames were used to work against in the same way as the knees were added to the flatners. However, sometime towards the end of the nineteenth century it seems that there was a change in practice, with steamed ribs being added subsequent to the clinker strakes being fitted, in what is regarded the normal practise nowadays. Only one, the *Una*, is said to have been carvel-built.

Ann, unusually, has nine planks either side rather than the normal seven. She was initially sprit-rigged and painted white with contrasting sheer strakes. At some time before 1963 she had a cabin added and was converted to gaff rig. That year she was bought by Major W. D. Martin for £200 from H. V. Adwin Joyce. By 1967, she had been painted summer blue and the cabin white. His daughter Ann still has fond memories of the boat. In 1979, he sold her to the Flat Holm warden and by the mid-1980s she was for sale for £1,488, complete with a mooring at Uphill. By 1994, she had been bought

by Angus McArthur and Stephen Lowe from a J. Dash for £600. She sailed to the International Festival of the Sea at Bristol, at which time she was painted green above a red waterline, with varnished sheer strakes standing out once again. At some point in her early life she was engined and when she was bought by the Somerset County Museums Service in 2001 and placed in the care of the Watchet Boat Museum, she had a Brit Minor petrol engine, No. 2262. Since 1996 she has not been in the water, though it is the intention of the Museum to restore the boat and eventually sail her again, an event that is widely looked forward to.

Lastly, one interesting fact comes from Eric McKee, who states that the sails were usually made by the fishermen themselves at home. One such fisherman, Jack Glover, was both a seaman and sailmaker, as well as making blinds and shop awnings. Some, however, had their sails provided by tobacco manufacturers, who then insisted that advertisements for their goods were displayed upon the white mainsail. Fishermen usually tanned their sails after some usage, though those with adverts couldn't and had to wait until they could persuade the company to part with another suit. Imagine that today, when it could well be illegal to display tobacco goods in a shop. How daft, and controlled by over-zealous zombies, we've become.

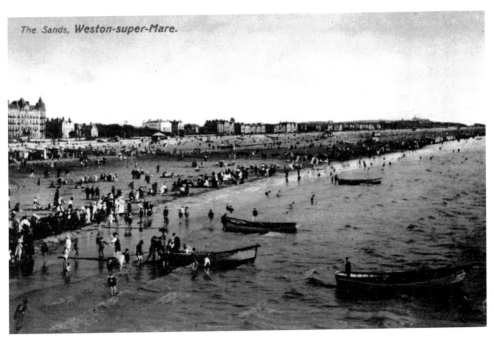

The Sands, Weston-super-Mare.

The beach at Weston-super-Mare, a large, extensive sandy beach from where the fishermen operated their tripping boats.

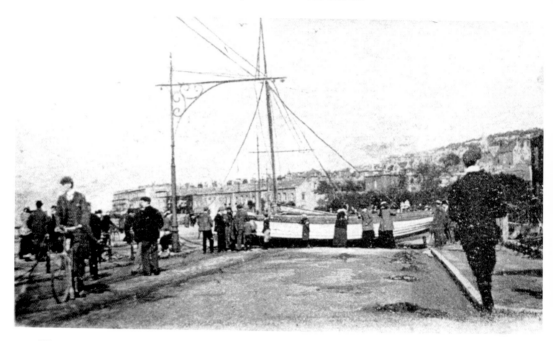

Weston in September 1903 after a gale that blew a flatner onto the road at Knightstone Harbour. The boat shown is approaching 30 feet in length, one of the largest Weston flatners.

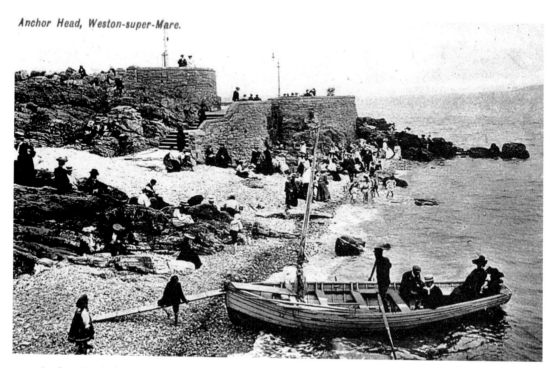

Anchor Head – between Knightstone Harbour and Birnbeck Pier – with Victorian trippers waiting aboard a flatner. A simple gangplank was all both men and women had to climb aboard.

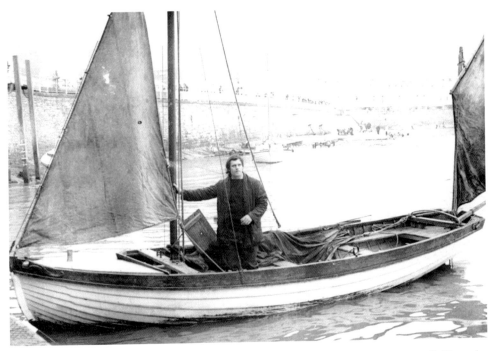

A typical sailing flatner with small lug mizzen, foresail and lowered gaff mainsail. Note the raised daggerboard.

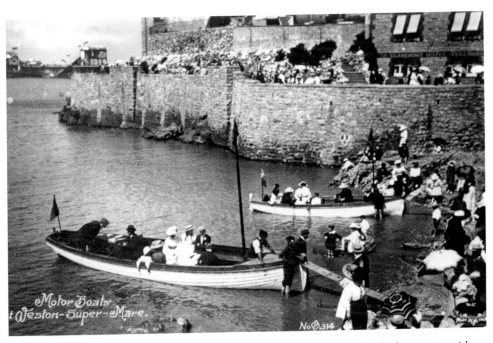

Knightstone Harbour in the 1930s. The boats have been motorised and sails done away with.

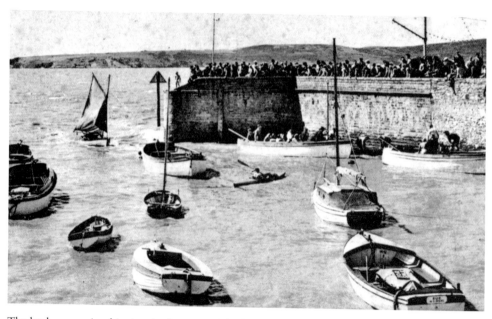

The harbour again, this time in the 1950s. The boats are busy, judging by the number of visitors on the quay, and a couple appear to be carvel-built.

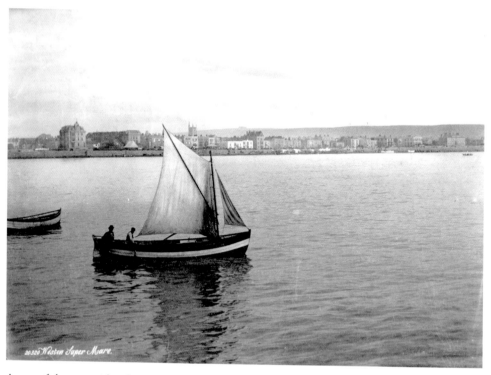

A peaceful scene with a flatner sailing past the town.

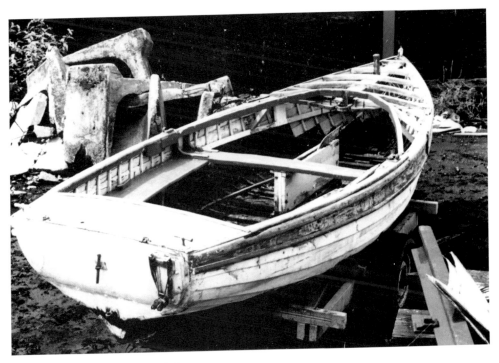

The flatner *Lisa* looking a bit forlorn.

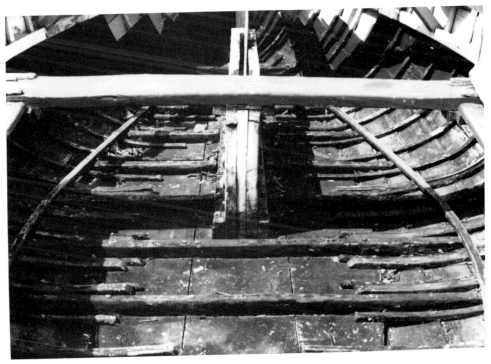

An internal view of *Lisa*, showing the flat bottom

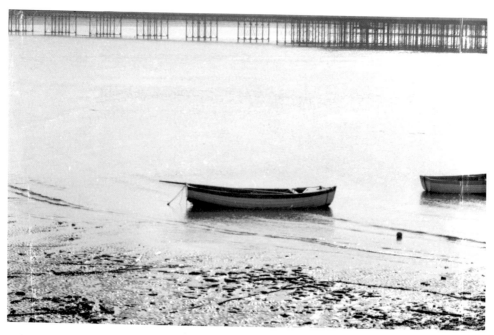

A flatner anchored in front of the pier.

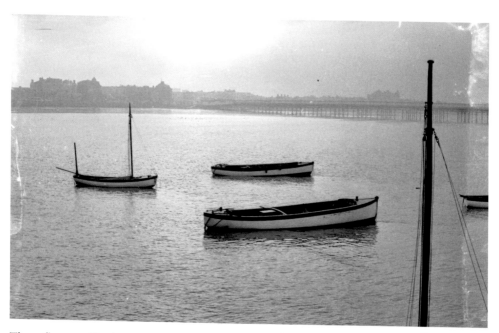

Three flatners. The largest in the foreground has a cruiser stern, which is unusual for these vessels and leads to the suggestion that it isn't really a flatner.

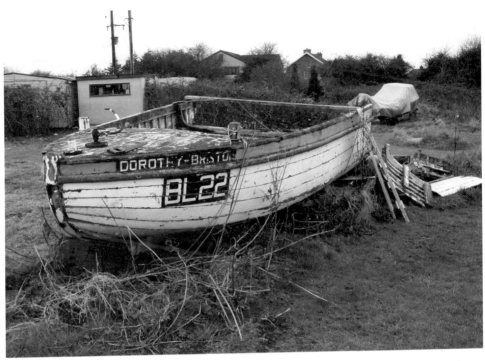

Another vessel with a cruiser stern, *Dorothy*, although she once fished from Weston before being chopped up, isn't a true flatner.

The remaining photographs are all of the flatner *Ann*:

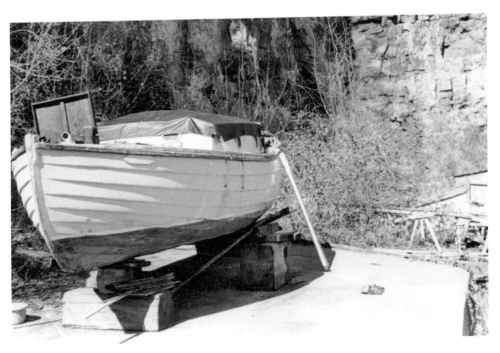

Ann in her winter quarry berth.

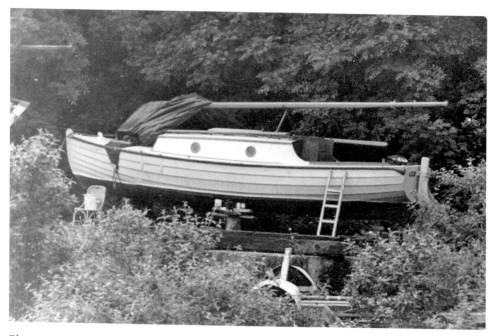

Elevation view. The cabin was added in about the 1950s.

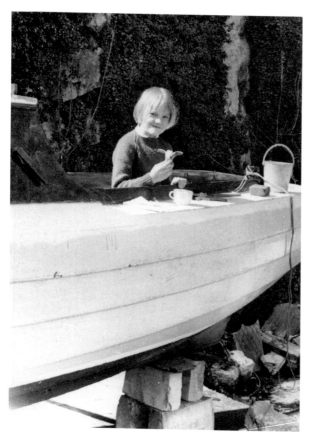

Ann painting *Ann*. Ann is the daughter of Major W. D. Martin, one of the owners, and still remembers working on the boat.

Showing the flat bottom of *Ann*.

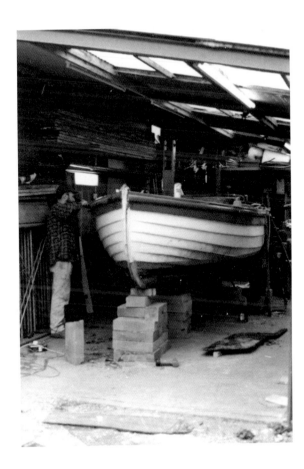

Ann in the boatshed being painted
with varnished gunwhales.

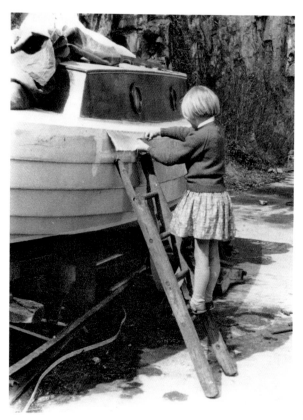

Ann again, removing a fibreglass patch.

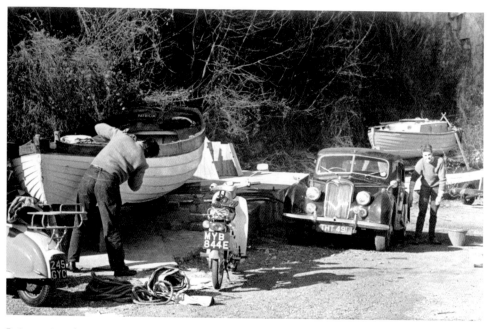

Being painted again, though the two- and four-wheeled vehicles are more of interest in this photo.

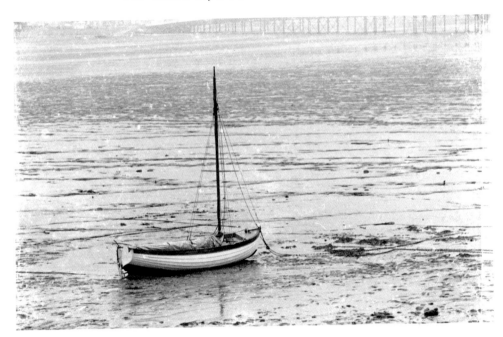

Ann on the mud at Weston.

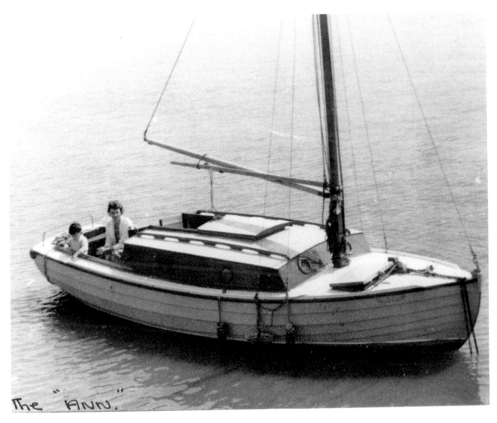

An overall photo of her in the 1960s.

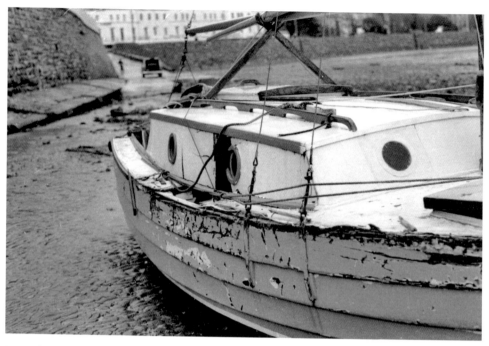

Here she has sustained some damage to her starboard side after colliding with another boat during a serious gale. Date unknown.

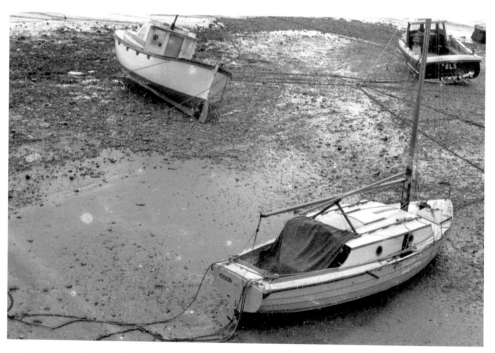

Lying among other craft in Knightstone harbour, a cover protecting her cockpit.

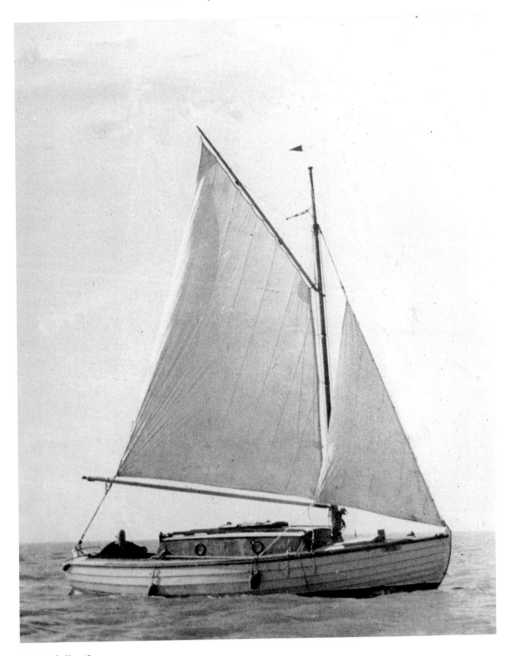

Under full sail.

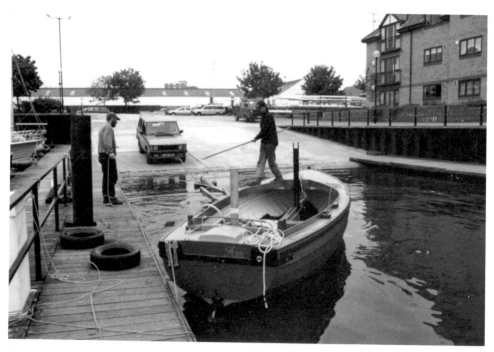

Being launched prior to the International Festival of the Sea, Bristol 1996.

Sailing along the River Avon.

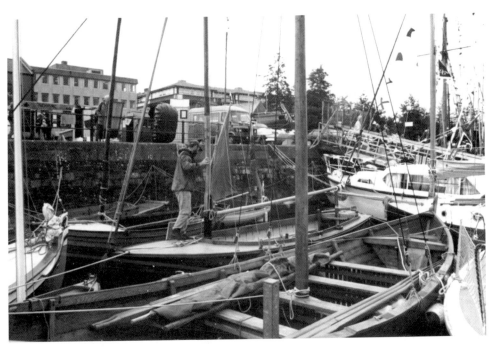

Moored by the Mud Dock, Bristol, during the festival. In the background is the author's 'Herring Exhibition', the first time this exhibition appeared in public!

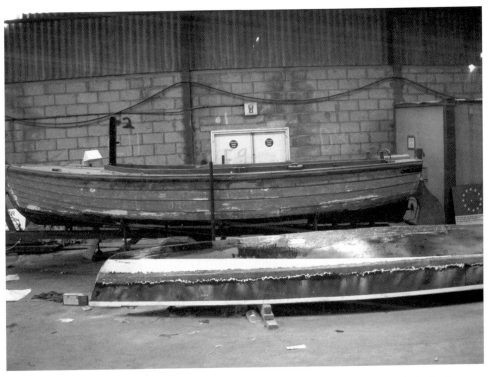

Ann today in the hands of the Watchet Boat Museum and under restoration in their shed.

Chapter Seven

The Bridgwater Barges

The opening up of the area in the eighteenth and nineteenth centuries, as roads and canals forged links with what had previously been the outside world, affected both the social and economic life of the inhabitants. Both the rivers Parrett and Tone were being used for the movement of goods as far as Taunton at the beginning of the eighteenth century. The Avon had been made suitable for vessels to reach Bath in 1727. Coal was brought across from South Wales and taken to towns such as Ilchester. In 1827 the Bridgwater and Taunton Canal was opened between the River Parrett at Huntworth and Taunton, despite opposition from landowners and the Conservators of the River Tone, a group of 'gentlemen' who set themselves up to administer that waterway. In 1840, it carried 90,000 tons of freight. In 1838 the canal linked with the Grand Western Canal to Tiverton, and in 1841 the harbour was built at Bridgwater and a connection was being built to the canal. The following year, the Chard Canal down to Chard from its intersection with the Bridgwater and Taunton Canal at Creech St Michael was opened, mainly to ship coal and other freight to Ilminster and Chard. But already the railways were beginning to dominate the movement of freight and when the Bridgwater to Taunton railway was opened in 1842 by the Bristol & Exeter Railway Company, the writing was on the wall for the canal owners.

However, the initial planning had been much more adventurous during the days of canalmania in the second half of the eighteenth century, and into the early nineteenth. The main desire seemed to be the construction of a route that linked both the Bristol and English Channels to save vessels the journey around the south-west peninsula and the hazards of Land's End and the rest of the Cornish coast. Some suggestions reckoned that four weeks' time could be saved by a through-route overland, although presumably that was in very adverse weather and tide conditions and in small vessels for so much time to be saved when even traversing a canal would take a few days at least. Furthermore, at the time, with more shipping around the notorious south-west coast, the number of those that failed to make the passage and became wrecked on the various reefs was also growing. The loss of shipping and life was quite dramatic and a canal across the south-west peninsula would go somewhere to reduce this in terms of English shipwrecks.

As early as 1768, famous canal builder James Brindley was commissioned to survey the route from the Bristol Channel to Exeter using part of the River Tone. One problem was that the canal would have had to rise up 300 feet, no easy task in the early days of canal building, and thus the plan got no further.

The following year, a route down to Seaton using the rivers Parrett and Axe was investigated, though again nothing further happened. In the 1790s, with more experience in canal construction, further plans were discussed, including building the Grand Western canal between Taunton and Tiverton, the Kennet and Avon Canal linking the west with London and one between Bristol and Taunton via Bridgwater. The Kennet and Avon Canal got underway in 1792 and the Grand Western four years later. Once the Kennet and Avon was opened in 1810, this revived the question of linking the two great Channels in the mind of John Rennie, who had been responsible for the Kennet and Avon. He proposed a ship canal from the mouth of the River Parrett to Burrowbridge, where it crossed the River Tone, thence south to Langport and the summit near Chard, and from there to the River Axe, joining the English Channel at Seaton. Again, this idea was abandoned, largely because the lack of money.

However, next came a plan in 1822 by James Green, the engineer on the Bude Canal, who proposed a canal similar to that of Bude, leading from the Bridgwater and Taunton Canal near Bathpool (the canal was at the planning stage then) to the picturesque fishing village of Beer in Devon. Beer would get a pier which, for what was (and still is) a beach-based fishing community, would certainly be acceptable. Boats were to be hauled up inclines instead of pound locks to raise the water level. But again the plans were shelved.

It was Thomas Telford's turn next. He designed a ship canal from the north down to a new harbour at Beer which would again be utilising part of the Bridgwater and Taunton Canal, which was, by 1825, being cut. This part would be widened to accommodate the large vessels he envisaged. The whole scheme, with its costs escalating, seemed to get out of hand, especially when a harbour was added at Stolford instead of at Combwich and when the canal was re-directed to Taunton, where goods could be trans-shipped onto the Bridgwater and Taunton Canal. In the end it was all decidedly too expensive and, with the railways already bringing an end to the canal building period, this again was shelved, as was another planned barge canal between Beer and Bridgwater.

Nevertheless, with Bridgwater emerging as an important trading harbour for both national and overseas shipping and a brisk trade developing along the River Parrett, most notably for the growing brick and tile trade, the canal to Taunton was eventually opened, and the Bridgwater harbour three years later. The scene was set for a thriving industry. Bridgwater got its connections to Taunton, Tiverton and Chard and no more.

Bridgwater has been described as being the Hong Kong of Somerset, a slightly more amusing than technically correct similarity given the muddy Parrett and the lack of Hong Kong's financial, social and culinary traditions. Nevertheless it makes the point that, although not the gateway to the East, the town was the gateway to Somerset. There was a 'rich mixture of entrepreneurs and traders, free thinkers, nonconformists, translators and inventors' according to James Croden and Pauline Rook. Complex, colourful and cosmopolitan was how they described it. The town's trade went to Ireland, Scandinavia, the Baltic and Russia, the West Indies and the North American continent and the Mediterranean. Wool, wine, woad, iron, cider, timber, grain, millstones, coal, sheep and cattle all passed through, as well as the bricks and tiles. Thus the wharves abounded with activity as goods were loaded or unloaded from the myriad of sailing vessels to be shipped onward, usually up river or canal.

It was against the backdrop of the burgeoning canal network that the Bridgwater barge evolved. Whether it was planned on similar lines to the small boats of the

waterways is unclear but there is what would otherwise be a strange similarity. They were flat-bottomed and shallow-draughted, which made them ideal to operate over the shallow River Tone, especially between Ham Mills and Taunton. They were necessary because the road bridge in the middle of Bridgwater meant that no sailing vessels could proceed further up river. Goods were therefore transferred aboard the barges for shipment up the Parrett or along the River Tone to Taunton. Parrett barges were up to 66 feet in length and 13 feet in beam. Once the Bridgwater and Taunton Canal was opened, the maximum size able to pass through the pound locks was 52 feet. These double-ended barges were able to carry up to 25 tons of freight.

The flat bottoms consisted of several planks, again non-edged joined, with clinker sides, oak floors and frames. What made them different from other Somerset craft was that they had curved sides and apparently had similarities that reminded ethnologists of the medieval cogs, the clumsy-looking trading vessels of northern Europe of that time. The barges were propelled by being tracked along the tow path and a large tiller steered the vessel. For stopping, drag chains were thrown over the side to 'ride the bottom', these being affixed to three naturally forked, Y-shaped timbers called *livers* which were attached to the forward bulkhead. Forward of this was a decked area with cuddy below which contained all their ropes, lamps and gear in general, as well as a stove and seating area. Some had a smaller decked area at the stern behind the steering well. Smaller barges, capable of carrying 15 tons, had no sheltered areas.

They were normally crewed by two bargemen who did not sleep aboard – the canal was only just over 14 miles long and could be traversed in one day. Many also took on the services of a boy who undertook the menial work such as attending to the horse, opening lock gates and looking after the tow-lines.

Barges were mostly built at Bridgwater. Messrs Stuckey and Bagehot had their own fleet, which they built and maintained at their yard. Sully & Co. were large coal importers and had their own fleet. Messrs F. J. Carver and Son, at the East Quay, built barges as well as larger ships such as the last remaining West Country trading vessel, *Irene*, built in 1907. Many of the brick and tile manufacturers in Bridgwater or lining the River Parrett had their own barges, which were built locally.

Although barges were engaged moving freight into the hinterland, many were occupied with the business of carrying coal to the Bath brick kilns upstream and returning with a cargo of the bricks to transfer aboard one of the ships that traded them far and wide. The *Irene* was one such vessel, owned by the Bridgwater Brick & Tile Company, and she spent the first part of her working life sailing between Bridgwater and Ireland with loads of bricks.

Other barges collected the slimey silt from the river estuary, which was used in the manufacture of Bath bricks, and for cleaning and scouring around the home. Pebbles for use as cobbles, and sand for the brick and tile industry and for the other multitude of uses it has, were also collected from the estuary at low tide and brought to Bridgwater.

By the 1920s the traffic on the canals had decreased to almost nothing, so that by 1930 the last barge had disappeared. Sadly, unlike so many other examples of barges in use in Britain inland and on the sea in the heydays of sailing vessels, no original Bridgwater barges remain today. Furthermore, unlike the Somerset flatners and flatties, no replicas have been built.

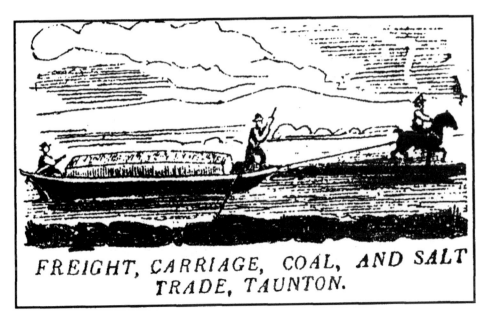

An early nineteenth-century illustration of the Taunton waterway, advertising the daily courier service of H. Trood & Sons.

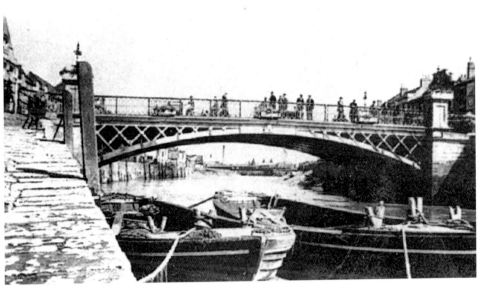

The bridge in Bridgwater that prevented sea-going ships from progressing upriver, thereby neccessitating the transfer of goods onto barges.

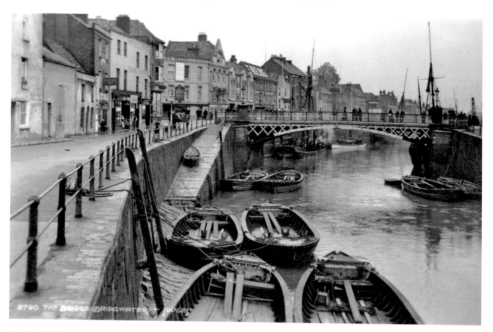

Probably the best photograph of barges, taken about 1870, by the bridge in Bridgwater.

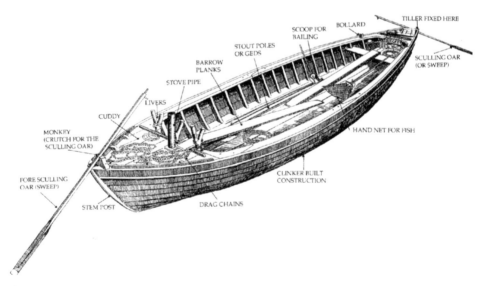

A drawing of a Bridgwater barge by Edward Paget-Tomlinson, from his book *Britain's Canal & River Craft* (Broughton Gifford, 1979).

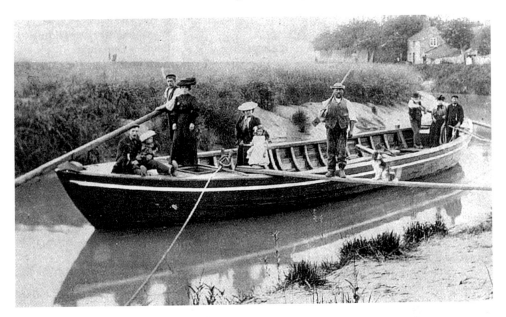

An outing upon a barge on the River Tone *c.* 1910.

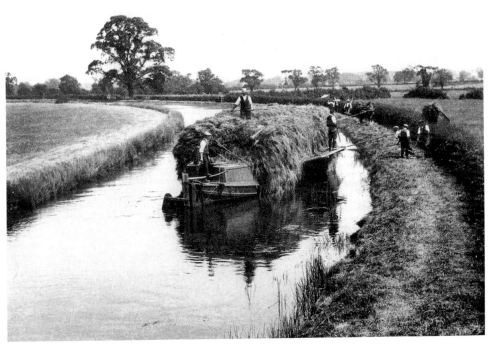

A barge with outriggers attached collecting the hay from the canal side to keep the tow path clear. Weeds were also a huge problem by the canal bank.

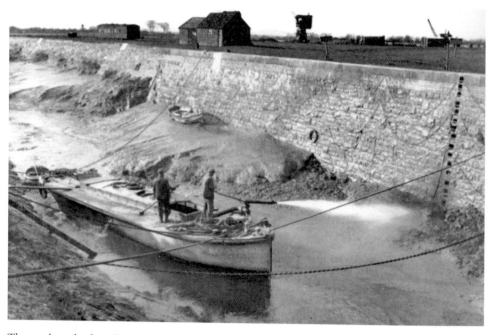

The modern dredger *Persevere* working to clear the canal sides with jets of water.

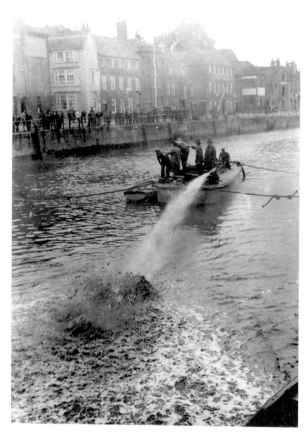

Here *Persevere* is demonstrating her abilities to the people of Bridgwater.

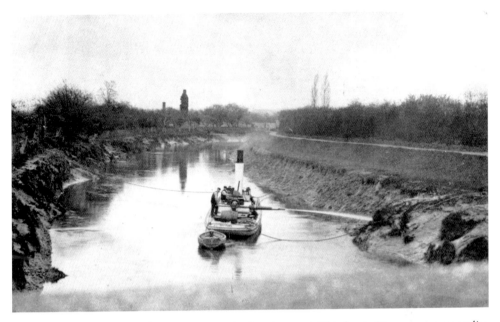

There have been various other attempts to dredge the canal. This boat, *Pioneer*, was an earlier vessel.

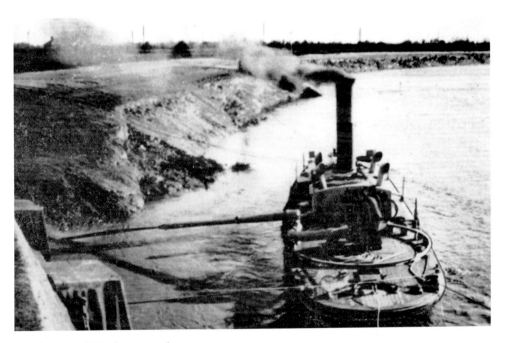

Another vessel, *Eroder*, at work.

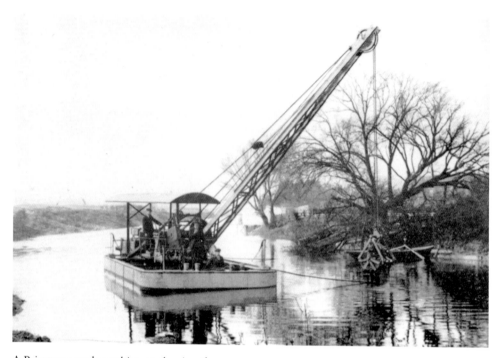

A Priestman grab working at clearing the waterway.

No book on Somerset vessels can fail to mention some of the trading vessels built in Bridgwater. In the following photographs a few of these are shown.

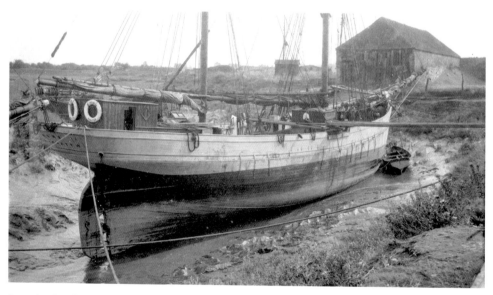

Irene in Combwich Pill. *Irene* is the last remaining Bridgwater-built West Country trading vessel and is often moored in Bristol.

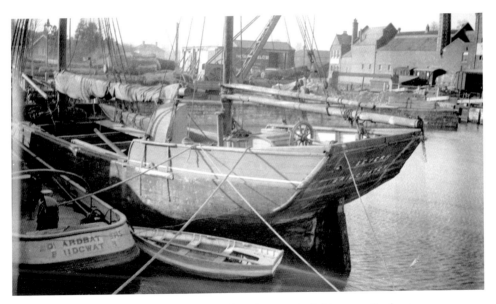

The Severn trow *Severn* alongside the tug *Edward Batters* in Bridgwater Docks.

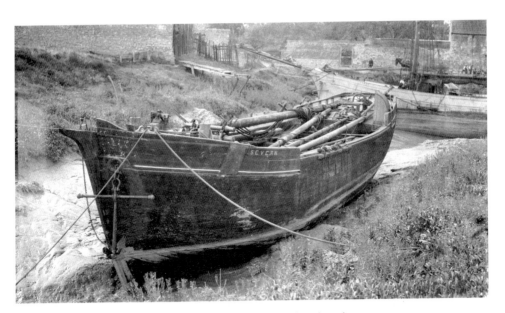

Severn at Combwich with her masts down and looking abandoned.

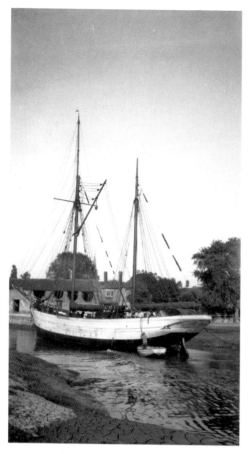

Sunshine at Combwich.

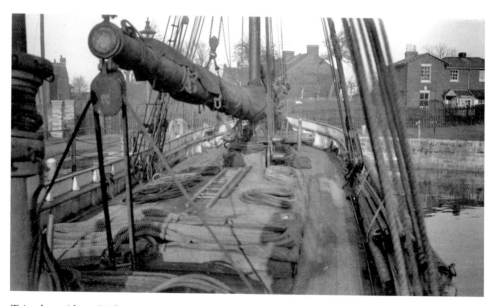

Trio alongside at Bridgwater.

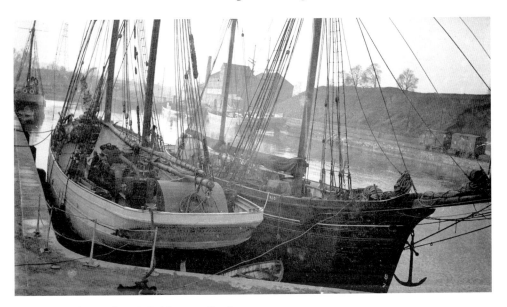

Trio alongside *Sunshine* in Bridgwater Dock.

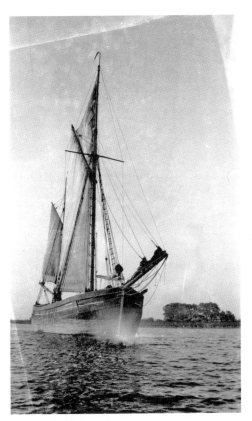

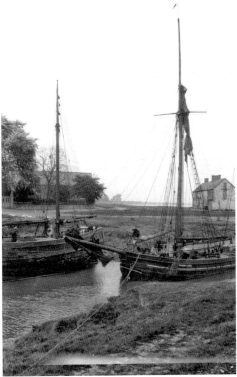

Above left: Fanny Jane under full sail.

Above right: Fanny Jane heavily laden at Combwich.

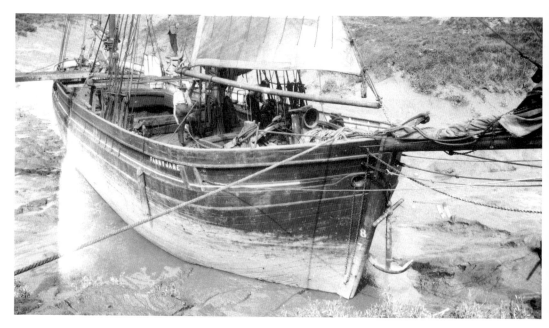

Fanny Jane. Deck view of *Fanny Jane* dried out at Combwich.

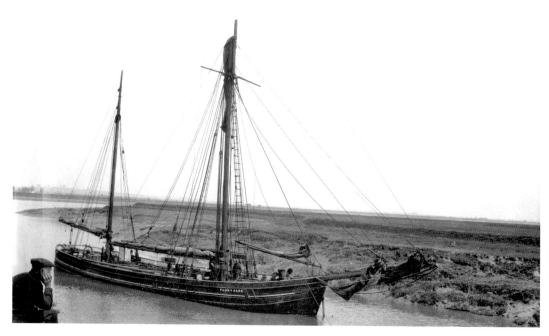

Fanny Jane coming into Comwich Pill heavily laden.

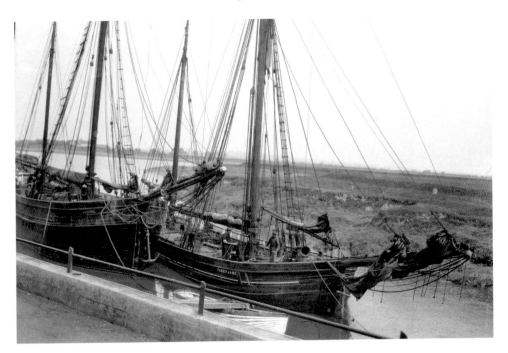

Fanny Jane in Combwich Pill.

Bridgwater Canal, although navigable,
sees few vessels these days.

Chapter Eight

The People Who Built, Sailed, Fished and Generally Used Them

Highbridge was a surprisingly busy little haven upon the River Brue in the late eighteenth century. Together with the river, it had provided Glastonbury and its Abbey with a link to the sea. Some even go so far as to say that this short but colourful waterway brought temporary prosperity, thus saving the town from certain decline. Ships landed their goods, such as corn, fish and wine, upon the wharves at Highbridge and these were taken up-river by barge. Such was the prestige of Glastonbury that a canal was built between 1827 and 1833, following much of the route of the river, the total length of the navigation from the junction of the rivers Brue and Parrett to the west side of Glastonbury being 14 miles. It is interesting to note that, according to Joseph Priestly in his *Historical Account of the Navigable Rivers and Canals and Railways of Great Britain*, the tonnage rates for the Glastonbury Navigation for coal, culm, coke, cinders, charcoal, timber, iron, bricks, tiles, stone, slate, turf and manure were 1s 6d per ton while for cheese, timber, and other goods, wares and merchandise, they were 3s 0d a ton. Proof, then, that it was a busy little waterway.

Sadly little is known about the barges that worked this waterway, though it has been suggested that they were trows similar to those that sailed up the rivers Wye and Severn and further afield. Furthermore, it is known that the canal company had two 45-ton barges of their own which had initially been designed for carrying turf from the Meare area, and that 25-ton barges also carried freight after it was transhipped through Highbridge from ships.

Then came the railways, the first Somerset railway being that between Bristol and Bridgwater which passed through Highbridge in 1842, bringing with it added trade. This extra trade wasn't to last long. Twelve years later, the Somerset Central Railway between Highbridge Wharf and Glastonbury opened along the route of the canal. This railway later amalgamated with the Dorset Central Railway to form the Somerset and Dorset Joint Railway, a cross-country route from the Bristol to the English Channel. This was, of course, the original desire of the canal planners. Although this route linked Burnham to Poole, the route was never successful due to its complexity. During the building process the canal enjoyed a brief revival, carrying materials used in the construction project. However, it didn't last long and, with the railway being sited along the towpath of the canal, it killed off what trade the canal had managed to keep until that date. Throughout Britain, though, as is known widely, the growth of the railways was at the expense of the canals, just as the development of the motor

car resulted in a decline in the railway which led to the 1962 rationalisation by Dr Beeching and the closure of many of the country's branch lines.

Highbridge, however, was home to arguably Somerset's best known boatbuilder. Harold Kimber – known as Kim – worked from his yard on Highbridge Wharf – in the area previously known as Clyse Wharf – after he had established his business in 1927. Kimber was responsible for building dozens of boats, including many flatners. He also built for the Admiralty during the Second World War and undertook service work upon RNLI lifeboats. Furthermore, he produced several yachts, including the Uffa Fox-designed *Fresh Breeze*, one of the largest he built. In all, it is said that at least 200 clinker-built vessels left his yard, including several motorised Weston flatners, as already mentioned in an earlier chapter. In the early 1970s, at a time when he was often being referred to as a master builder, he was commissioned by the National Maritime Museum to build a replica of the Gokstad *faering*, the original having been discovered in a ship burial in Norway and dating from AD 850. However, it would appear that, in general, Kimber was the only full-time boatbuilder building the flatners, as the majority were built either by the farmers/fishermen themselves or by itinerant skilled workmen capable of building a boat or a shed. It must be stressed, though, that Kimber was a general boatbuilder with an excellent reputation in all the boats he built. He also built his own yacht – *Brue Gull* – in which he would sail away for extended periods. An apprentice eventually took over the yard, which closed in the 1980s.

One of the flatners that Kimber had worked upon was largely responsible for the revived interest in these vessels. Known now as 'Kim's Boat' and on display at the Watchet Boat Museum, this boat was built in 1925, though it is not known who the builder was. It was originally a three-strake boat, but Harold Kimber restored it in the 1950s using plywood for the sides, as was the fashion of the time, after which he donated it to Bristol's City Museum, who then passed it on to the Somerset Rural Life Museum at Glastonbury. In 1996, this was 'borrowed' by residents of Watchet to publicise a possible community-run harbour after the docks closed. What was referred to as a 'Somerset fishing boat' at the time was subsequently restored and sailed up the River Avon to the International Festival of the Sea in Bristol in 1996. More on this boat in the next chapter.

The Sherring brothers used to build flatners at Dunball. Although they normally worked at the wharf during daylight hours, they occasionally sailed and fished in their own boats. They also built flatners on a casual basis when asked to in their spare time. One survived at Dunball wharf and this was similar to those built by Les Pople. It has since disappeared from Dunball and its whereabouts is unknown.

Les Pople was a traditional River Parret fisherman who built at least four of these boats. He started fishing in 1953 and, like the Sherring brothers, worked at Dunball wharf for many years. He remembers that a dip net licence was about 10 shillings when he started and that by the time he finished fishing in the early 2000s, it was £55, the same as for 50 putchers (sometimes referred to as butts, to confuse the dear reader). He had two ranks of putchers, one at Datchette and the other at Marchant's Reach, both on the River Parrett. Again, he can only fish from June to August and some years they only caught single-figure numbers of salmon. One year, though, he admits to catching a hundred salmon! Weights varied, with the maximum being about 19 pounds. That

was quite a fish to carry home on a bicycle, his favoured mode of transport from the putchers.

Henry Wilkins was associated with the building of flatners around the turn of the twentieth century. It seems that he came from a family of fishermen dating back to at least William Henry Wilkins, who was born in 1844 at Combwich.

John Parrish, who lived at Pawlett, was apprenticed to Harold Kimber during the Second World War. He built WBM 'Number one' boat for his own pleasure in his evenings during 1946 from what wood he could find. The bottom was elm, pinned with copper nails, while the sides were of larch. He was a member of Burnham Yacht Club and he raced the boat. Sometime later this flatner then went to Cliff Wilkins, who ran Pawlett Post Office, and thence on to Black Rock fisherman Bob Thorne.

John Carter is known to have built one in 1947, this boat costing £1 17s 6d, including the sails. Frank Webb, as we've already seen, was a well-respected builder of at least one Weston flatner.

Bill Pocock, known as 'Pokey', was renowned for fishing with a dip net from the river bank in a particular street in Bridgwater – known as Salmon Parade for obvious reasons – near where he lived. It was legal, according to bylaws, to fish from the riverbank in this way, though not on a Sunday, as long as a licence was held. To do this, a dip net was used, but this had to be used in a particular way, in that it couldn't be dipped, as it would be from a boat, but whacked down instead. Bill Pococke, dressed in his trilby hat, was particularly good at doing this! He was also renowned for building good boats.

But it is farmer/fisherman Bob Thorne, mentioned above and in chapter four, another traditional riverman like Les Pople, who should have the last say. He came from a family of river people who maintained ranks of putchers at Black Rock as well as holding fishing licences. Born and bred by the riverbank, he still lives in the thatched, sixteenth-century family house near Pawlett, approximately one mile from his putchers. As a child he was sometimes taken to Sunday School by boat – either a flatner, a withy boat or whatever. He was called up during the Second World War and became a medic. Afterwards, he returned to what the family had been doing for generations – digging, gardening, fishing, shooting rabbits and pigeons, tilling the fields – a bit of everything, in fact, including brief periods of jobbing at times, and has been doing the same ever since, though not as intensively these last years. Even in his eighties, he tends his apple trees, pear trees, cherry trees, plum trees, walnut trees, makes his own cider, grows his own vegetables. He has never been married and even today still claims to have had no interest in women. Thus, there's no direct descendant for him to hand over to and presumably a nephew or niece will inherit.

He started fishing with his own flatner in 1949. Bill Pocock had built it for him, though he had to run his dad's coal business that year so he didn't fish until the next. He caught his first salmon in May 1950, a seven-pounder.

Since then, he'd had licences throughout his fishing career for both putchers and netting. He had to cross several fields, climb over stiles, and trudge along the river twice a day to check his ranks. When the tide was bad, he'd either tend his stake nets or go dip netting or pitching. Then, when the ranks had to be dismantled at the end of the fishing season, he had to carry each and every putcher back on his own, a laborious

task in anyone's mind. Then, before the start of the season, he had to carry them all in the opposite direction, back to the river. Having somewhere in the region of 250 putchers in several ranks (fifty putchers to a rank was the maximum), of which it is only possible to carry a few at a time, meant endless journeys. He had a small fish shed by the river, the first of which was supposedly built by Joseph Reasons in 1852. In this he kept most of his fishing gear and today his last flatner, a glass fibre boat, still sits there rotting away. This fish shed, according to Bob, was still marked by Napoleonic cannonballs when it blew away a few years ago, though how this equates to being built halfway through the nineteenth century, long after Napoleon had died in 1821, is anyone's question. He's obviously a good story-teller.

Bob had several boats, though it seems he never built any. He donated much of his fishing gear to the Watchet Boat Museum which, despite various attempts by the Trustees to get him there (even organising a boat to take him on one occasion), he has never visited. He shopped by bicycle to Bridgwater and was probably one of a dying breed of those rural folk, refusing to travel further or, hell be damn'd, drive a motor car. His sounds an archetypical English life, straight out of, for example, Laurie Lee's *Cider With Rosie*, and at times it probably was a rosy way of living, away from the general stresses of life. Nevertheless, Bob Thorne is regarded as being the hardest and toughest of workers, a character fast disappearing in this modern country of ours, a loss to the social culture and to all and sundry. He, like many others, will surely be remembered for just that one day.

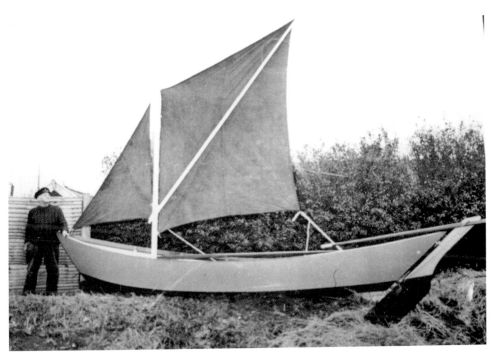

Harold Kimber with the newly restored boat now in WBM known as 'Kim's Boat'.

Bill Pococke with his dip net alongside the River Parrett on Salmon Parade, Bridgwater.

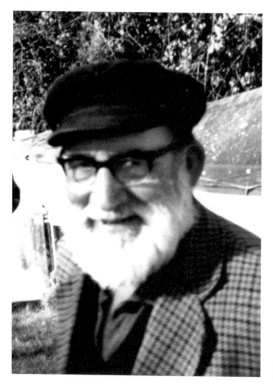

Bob Thorne.

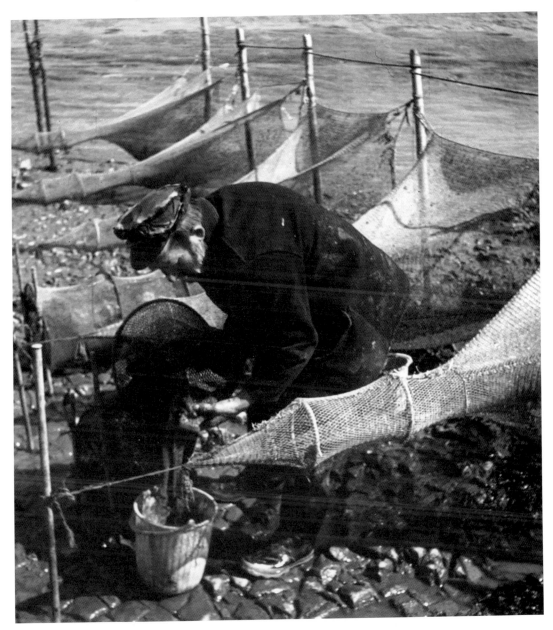

Bob emptying his stake nets.

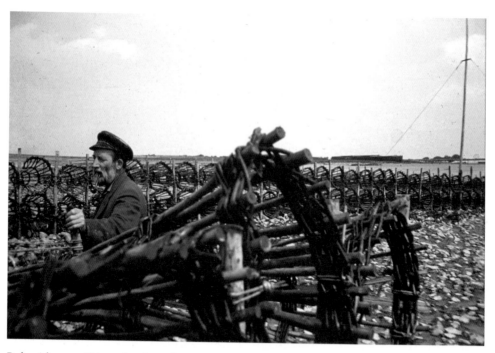

Bob with one of his ranks of putchers at Black Rock.

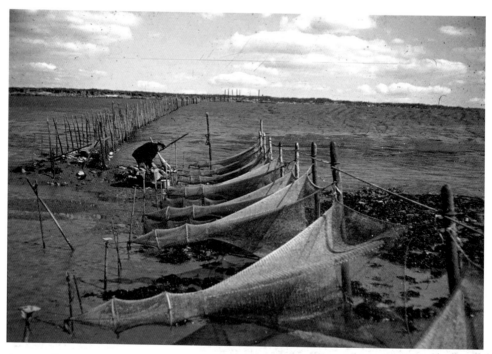

An overall view of his nets, which stretch right out into the river.

Bob demonstrating how to make a putcher. He made all his own during the winter months.

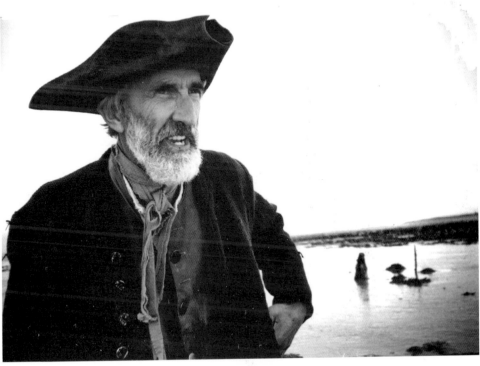

Bruce Scott at the filming of *Pandaemonium*. He has also been instrumental in forming the museum. Apparently having a grey beard is mandatory for all group members!

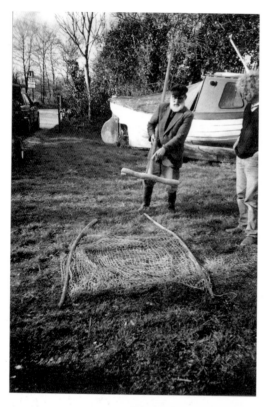

These pages: Bob demonstrating how a dip net is put together.

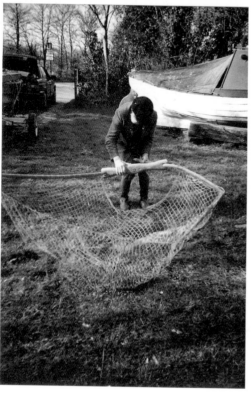

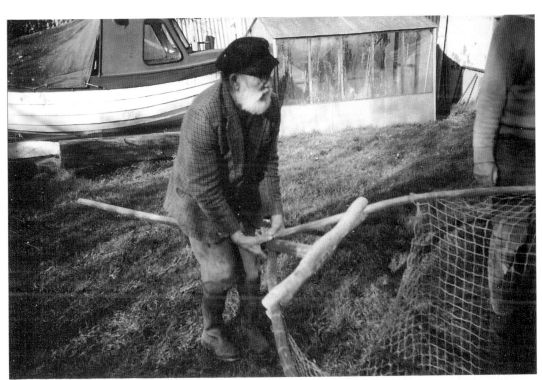

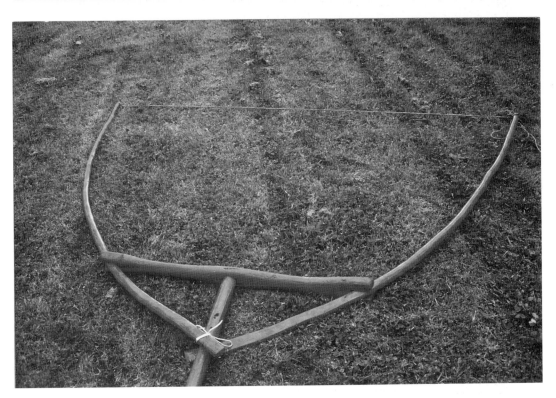

Chapter Nine

The Watchet Boat Museum

When Samuel Coleridge came to Watchet in the very late eighteenth century, little did he know that he was to leave his mark upon the ancient port. At the time there were many flatners in the harbour, though one doubts it was they that he described as being 'With sloping masts and dipping prow', as related in his epic *The Rime of the Ancient Mariner*, which was written during his stay. Although the poem gained international recognition, the lowly sailing *flattie* and flatner didn't and, as we've seen in previous chapters, they all but disappeared from the Levels and Moors, the rivers and estuaries and rocky parts of this part of the English Channel. That was until the revival and now, these days, it is Watchet where nearly all the *flatties* and flatners in existence are once again, for the town appears to be the only home of these small, unassuming craft.

It's here that I must be careful to discern between the two for otherwise I might suffer the wrath of the purest of pure puritans. *Flatties* to Watchet and flatners to the River Parret I know, but sometimes it's hard to speak collectively. Perhaps I should simply refer to them in this way as boats of the Somerset estuaries and harbours, although some might confuse them with the Weston boats. Others will say that there are none in Minehead. Luckily, the withy and turf boats never had sails so cannot be those referred to by the great poet. It is indeed a minefield for the unwary and I only mention this (towards the end of this book, mind) as a precaution. Let him who meanders along the path of history dare to write in and complain. There will be no mercy!

Anyway, we diversify from today's home of the boats of the Somerset Levels, Moors, Rivers, Estuaries, Burnham and Watchet! Let us end by exploring the Watchet Boat Museum and the craft therein. It is easy to find because, let's face it, Watchet is not a big place. As such, it is housed in the Old Brunel Railway Goods Shed, alongside the steam railway, close to the entrance of Watchet. It's free to enter – check opening hours – and inside there are several flatners/*flatties* of different sizes and vintage. The oldest currently is from the early part of the twentieth century, while two new boats are also on show. Fishing equipment abounds, as do old photographs and various other exhibits relevant to the flatners and their use or merely Watchet itself. The shed simply oozes flatner culture, as would be expected, but is as much about the folk who sailed and rowed the boats as it is of the boats themselves. It is certainly well worth a visit by anyone in the area.

However, how did it come about? Well, it seems it was almost by chance. In 1996, three local fellows, Bruce Scott, Tony James and Graham Coggins, had an idea about turning part of the derelict port into a community-run marina. The harbour had by then

ceased to work and lay idle although it was once a hive of activity, with wood pulp being imported from Scandinavia and Portugal for the local paper mill and general cargo passing through the harbour, including sand, cement, fertilizer, lead ingots, tractors, potatoes and coal. However, by the early 1990s only the ships of 'Willie Shipping' were using the port, bringing in timber from the Baltic and exporting tractors. It wasn't a hive by then but it survived for a bit longer before the inevitable happened. When they pulled out in 1993, the port fell into disrepair within several years and finally closed in 1999. Anyway, looking for ideas to publicise their plans for a marina, they decided that one way was to 'borrow' what had been referred to as 'the old Somerset fishing boat' which was owned by the Somerset County Museums Service and was in store at their Rural Life Museum at Glastonbury. This was the last known sailing flatner still in existence. Although the builder of this boat is not known, it is thought that it was built in around 1925. It was later restored by Harold Kimber in the 1950s. He had subsequently sailed it to Bristol and donated it to the City Museum who, thinking it more relevant to the Rural Life Museum, passed it on to there.

The three Watchet men did some work upon the boat, known as Kim's Boat and mentioned in the previous chapter. In deference to its status as the last remaining sailing flatner, they also had to purchase a new suit of sails, as the existing ones would have ripped to ribbons given the first puff of wind. They then were able to trailer the boat to the River Avon and sail up the river for the Bristol-based International Festival of the Sea in 1996. After a successful outing to the festival, the boat was taken back to Watchet and placed inside a derelict cargo shed, whereupon Tony James decided he would like to build a replica boat.

This, he decided, almost before he built it with his merry band of helpers, was to be called *Yankee Jack*, after arguably Watchet's most famous resident, John Short, otherwise known as Yankee Jack. Although during his lifetime (1839–1933) he sailed aboard trading vessels that ventured to every corner of the world, it was his voice that attracted the attention of those that heard him singing. Singing in one of the town's many pubs was a relaxation for many a sailor home from a long voyage, as was singing the same songs in far-off ports, with memories of loved ones back home. John Short was presumably no different and so he learned sailors' songs – known as sea shanties – from these far corners and introduced many back into Britain, saving many from extinction. Thus it is as the last and most famous of shanty-men that John Short is remembered in and around Watchet, and accordingly Tony James was inspired to remember the man in this way.

Building started in the railway cargo shed, alongside Kim's Boat. The three stalwarts were joined by Derek Vivian, who became technical director, and slowly the flatner grew from dished bottom planks of red Scandinavian pine to a complete boat with Somerset oak stem and sternposts, and plywood sides to lighten the boat to approximately half a ton. While building progressed, various people put their head around the door of the gloomy shed to see what was happening and when some bright person suggested putting a bucket out with a notice to encourage donations, money did, to the surprises of many, appear. Lights were obtained and some basic wiring undertaken to connect them up. Slowly, with the help of various people, the idea of a museum surfaced. In the meantime, *Yankee Jack* was launched in July 1997.

Very slowly at first, but with other boats lent, the space filled up as word got around and others offered them boats. Grants were obtained from various bodies and an exhibition was built. Tom King officially opened the museum in 1999 and since then it has opened every year in the summer months with free entry and is supported by donations from the 5,000 visitors each season.

Other than Kim's Boat, there are a number of other boats from around the county. The original clinker-built wooden boat, called Number One, was so called because of its registration number, which was painted on the side of the boat. It was built by John Parrish in 1946 out of whatever he could find. It was intended to be used as a leisure boat, so it was not as strong as the working boats. It eventually ended up with Bob Thorne at Stretcholt in the 1960s and he removed the daggerboard and used it for fishing in the River Parrett. Bob Thorne then built a fibreglass version of this boat and laid this boat up on block in his garden; he donated the boat to the museum in 1999, at which time it was in good condition, with a little bit of rot inside. It is now painted in the colours that it was when Bob used it – outside grey, inside white, bottom and first strake in black, and detailing such as the thwarts, gunwales, mast, bailer, priest, dip net, oars and mooring crook in red.

Boat Number Seven – an arbitrary label – was rescued from the banks of the River Huntspill after being found in a sorry state. It is said to be over eighty years old and has had the stern cut off and a transom added for an outboard to be fitted. It has no thwarts but simply a fixed box for the fisherman to keep his gear and sandwiches in.

Number Four boat was built by Les Pople in 1986 for fishing on the river. It has plywood sides strengthened by fibreglass and has a transom.

There are two turf boats, one being an original which was built by Mervyn Sweet in 1961 while the other is a 2/3 size model built by Coventry Boatbuilders during the 1986 Bristol Shanty Festival, since used upon the Shapwick Lake.

The Tub was built by Harold Kimber in 1948 and was later shortened to enable a transom to be fitted. She was a typical double-ended river boat of three-strake construction. However, much of the stern was removed when Kimber had got fed up rowing visitors out to Steep Holm and Flat Holm and added a transom to the boat as soon as he could get hold of an outboard. Today the boat resembles a short and fat tub, thus its nickname. It was rescued from the river bank, lying upside-down at Dunball, in 1999 and given to the museum by the owner.

The withy boat was built in 1930s and is typical of those of the Levels.

Some boats never made it to the Museum. The Cattle boat was discovered in a field belonging to a Mrs Christine Cattle at Burrowbridge. It was being used as a feeding trough for her ponies at the time it was found by the museum and the intention at first was to dig it out and move it back to Watchet. However, this proved impossible as the boat was in danger of completely falling apart. Students at Bristol University briefly studied it and it was assumed to be over a hundred years old. Eventually it was decided to leave it alone and presumably its remains are still in Mrs Cattle's field.

However, it is the Museum's patron, Gil Mayes OBE, C.Eng, MRINA, who has built two flatners in recent years. Gil is a time-served shipwright and a naval architect and he ended a 37-year career in the Royal Navy with the rank of Commander having spent seven years in design at Bath, specialising in nuclear, biological and chemical defence

systems in warships, so he knows a thing or two about boats. His first build, *Ostara*, is a near copy of Kim's Boat. This was built to the basic dimensions of a 'Bay' boat – i.e. 19 feet 6 inches by 5 feet 6 inches – although he said that he would have built to the maximum 23 feet but was restricted by the length of his shed). The boat has a bowsprit to reduce the weatherhelm and balance the boat. As he pointed out, this was not a problem to the fishermen, who would row downriver with the stream if the wind was unfavourable and then sail home with the prevailing westerly wind behind them.

Subsequently he decided to build a smaller boat, which he based upon the Combwich flatner as illustrated in the book *The Early Wars of Wessex*, 14 feet 6 inches in length with a 4-foot 6-inch beam, and the clinker-built *Emmet* arrived. This type of boat was used to go out on the ebb to tend the stake nets set out just below the low water mark by Steart Island, returning on the flood. Like the earlier boats, this one doesn't sail well except on a reach or with the wind right on the quarter.

He summed it up in his own words.

I have built several boats, from clinker dinghies to ply runabouts, but the challenge of a boat with a 1½-inch bottom and the forming of the same was interesting. With rise of floor and rocker keel it required a different approach to the one traditionally used – the planks laid in the ditch and weighted to induce a curve. I chose to cheat however and built the bottom upside down on formers (which were the floors) and laminated in two thicknesses of ¾-inch deal and epoxy. I was pleased with the end result which stayed pretty much true when we set up the bottom to receive the knees, although I did not remove the strong back until putting in the dagger board box. I would advise anyone contemplating a build to use this method.

With regard to the materials he used:

No special timbers were used or machined all being standard joinery material from the big timber yard, Snows in Glastonbury. I was fortunate in being able to pick and select for both *Ostara* and *Emmet* which made the build much easier. Again I would advise any builder to do the same and good quality deal and redwood is readily available at the big merchants at sensible prices. Use of these softwoods is acceptable as the whole hull, in both cases, was encapsulated in epoxy, well prepared and coated in paint.

Both these attracted interest until it was decided that a smaller, easily transportable boat should be developed. It was John Nash who decided to take on this project and design and build one that could easily be built using stock timber sizes and modern materials. John never regarded himself as having any remote connection with sailing, boat designing, boat building or carpentry and was equally determined that he would build this boat alone, although he did receive plenty of moral support from Bruce, Gil, Tony and his wife Rosemary. Called *John Short* and measuring about 12 feet 6 inches in length and 3 feet 8 inches across the beam, it was launched in 2007. It is an inexpensive boat which was again built on the lines of the Combwich boat. Plans of what is now called 'The Short Flatner' can be bought from the Museum. Plans of *Yankee Jack* are

also available. John's boat was later sailed around West Country creeks by Martin Hesp for a series of features in the regional newspaper. Also present at the official launch at the River Festival in Taunton on 16 September 2007 was Steve Rowbotham, Bronze Medalist, World Champion Mens' Double Sculls, 2007. Steve said: 'Obviously a little wider than I am used to but the flatner is an extremely stable and manoeuvrable boat that would be fun for everyone.'

Today, the Museum is run by the Friends of the Flatner Association, a voluntary group of dedicated enthusiasts, boatbuilders and sailors. The aim is to preserve the history of these craft, as well as collecting, preserving and using the boats as possible. It has the largest collection of Somerset boats anywhere in the world and is recognised as the home of the flatner. The exhibition also contains traditional fishing equipment, historic photographs and a rope-making machine. It is open in the afternoons (2–4 p.m.) every day between Easter and October, although special arrangements can be made outside of these hours. Please contact Bruce Scott on 01984-634242 or see www.wbm.org.uk or email greatscott@dsl.pipex.com.

The Ancient Mariner on today's Watchet Promenade, erected in 2003. (*Photo by author*)

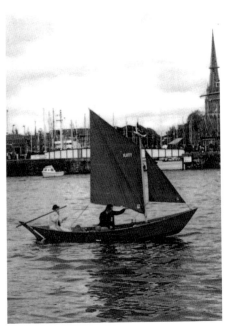 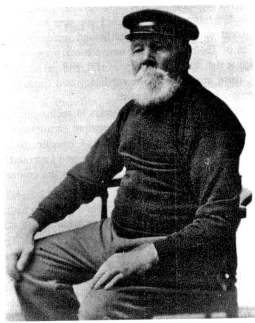

Above left: Kim's Boat sailing at the Bristol International Festival of the Sea in 1996.

Above right: John Short, known as Yankee Jack.

The other statue on Watchet's Promenade is of John Short gazing out to sea. (*Photo by author*)

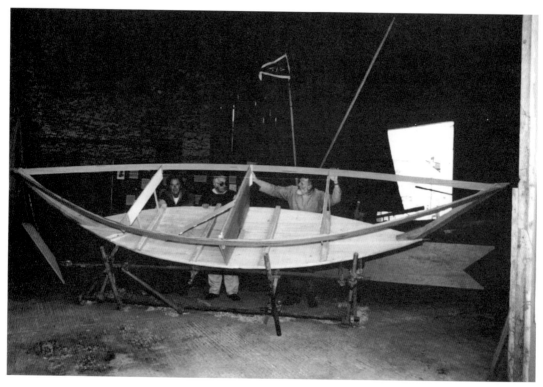

Above and below: Various stages of the building of the new flattie *Yankee Jack.*

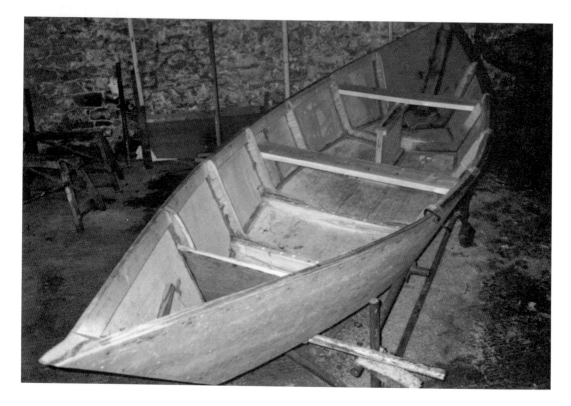

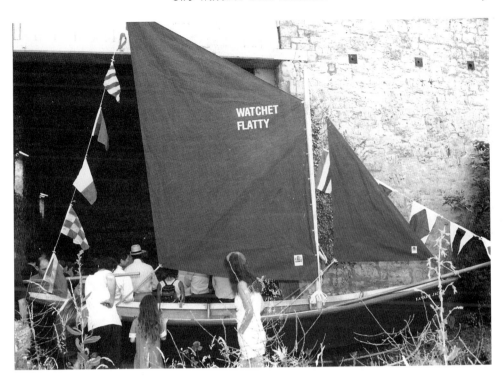

Emerging from the shed on launch day.

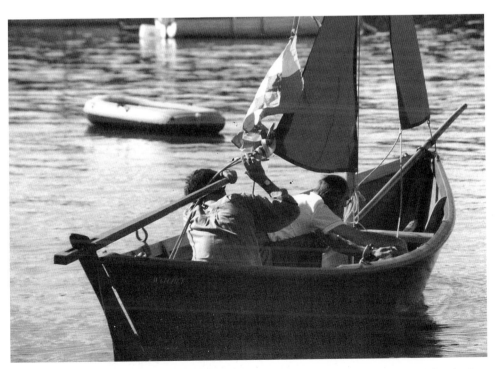

Above and next page: Sailing *Yankee Jack* around the harbour after being launched for the first time. To many this was a truly magnificent sight after so many years with no flatties in the harbour.

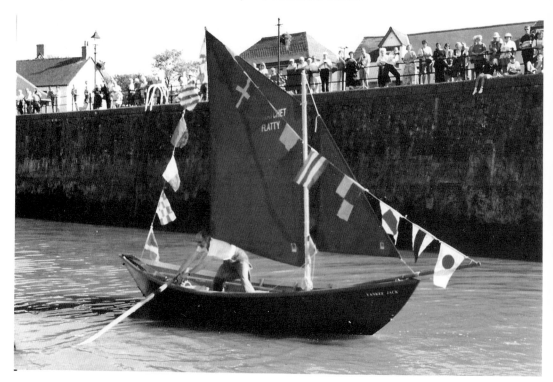

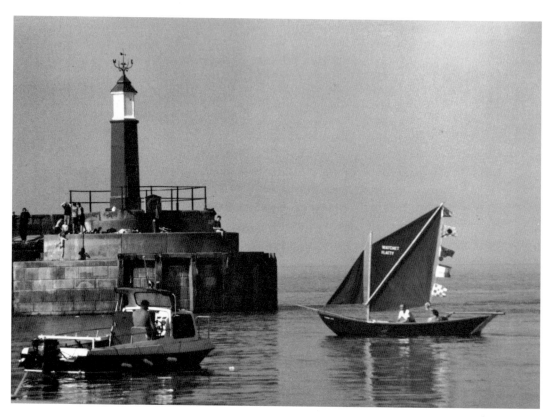

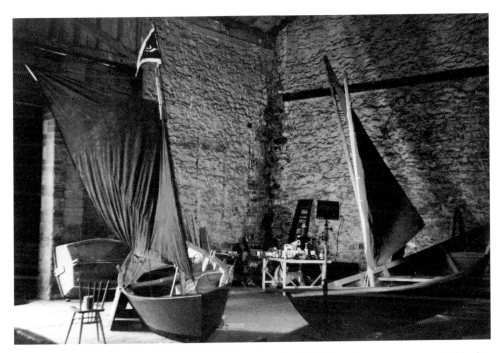

Kim's Boat and *Yankee Jack* alongside each other in the shed. Tony James, accompanied by his friend Wilberforce, sailed *Yankee Jack* right around the south-west peninsula, from Highbridge to Exeter, in 2002. After that voyage *Yankee Jack* was added to the museum to earn, as he put it, a well deserved rest. The story is told in his book *Yankee Jack Sails Again*. (*Photo by author*)

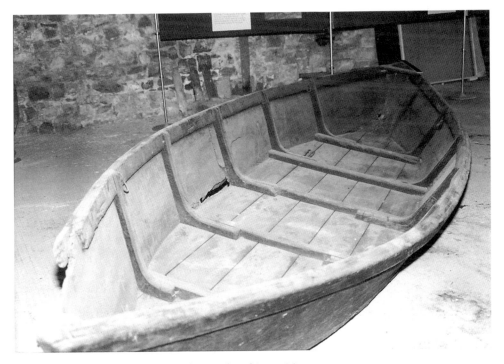

The withy boat from WBM before being placed in position.

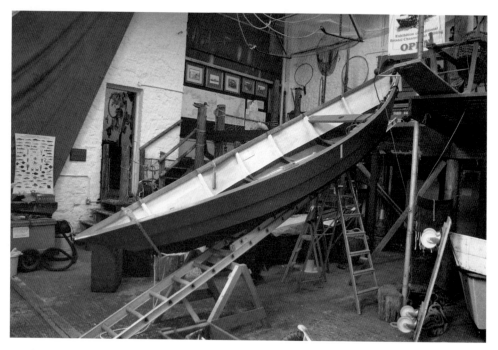

Hauling Number One boat up onto the upper layer, where she is on display today.

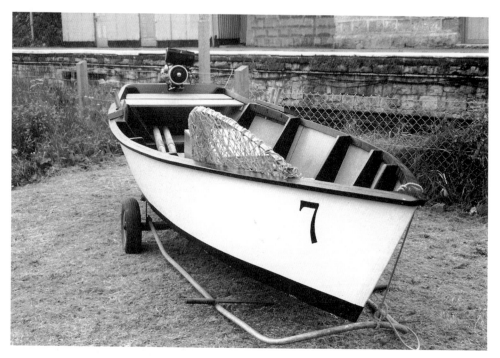

Number Seven boat, ready to be taken inside the Museum.

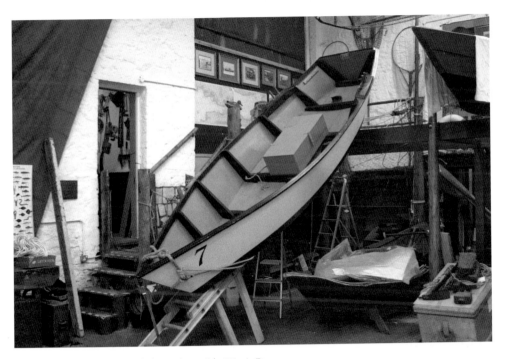

Number Seven being hauled up alongside Kim's Boat.

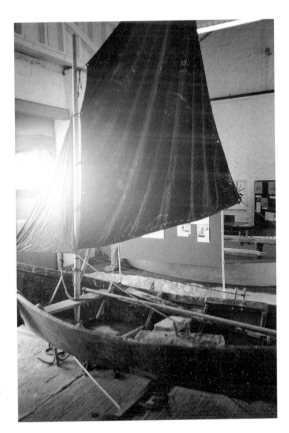

Number Four boat on display as a small playground for kids to climb about inside the Museum. (*Photo by author*)

Opening day in 1999. From left to right: Bruce Scott, Tom King, Tony Knight, John Nash and unknown visitor.

Museum's sign.

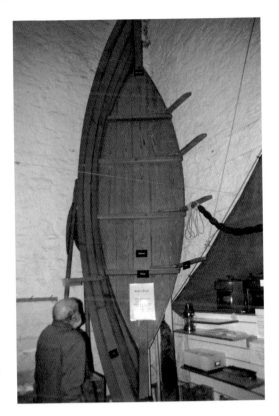

The partially-built Bob's Boat is on display to demonstrate how these boats are built. (*Photo by author*)

Number Four boat today. (*Photo by author*)

Kim's Boat today. (*Photo by author*)

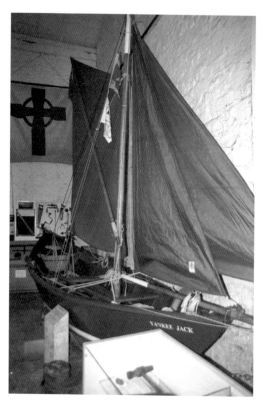

Yankee Jack today. (*Photo by author*)

The withy boat with the turf boat above.
(*Photo by author*)

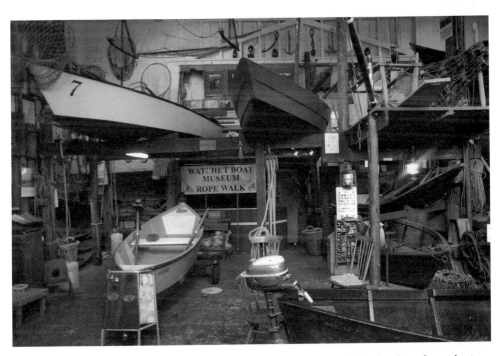

View with Numbers Four and One above and *John Short* on ground level. (*Photo by author*)

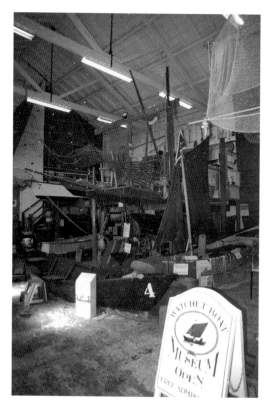

Overall view. (*Photo by author*)

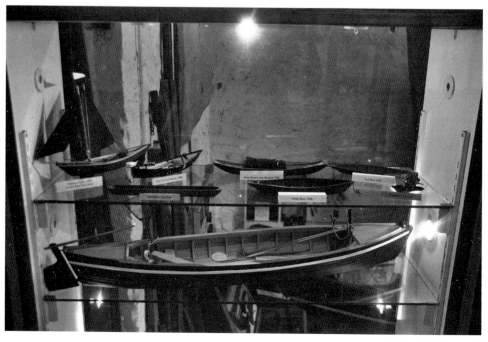

Model case with Bridgwater barge on the bottom and various flatners on top shelf. (*Photo by author*)

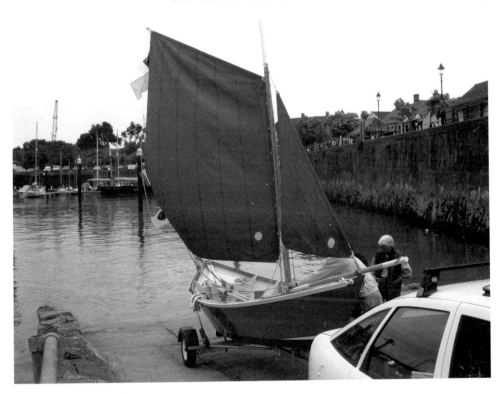

Ostara being launched.

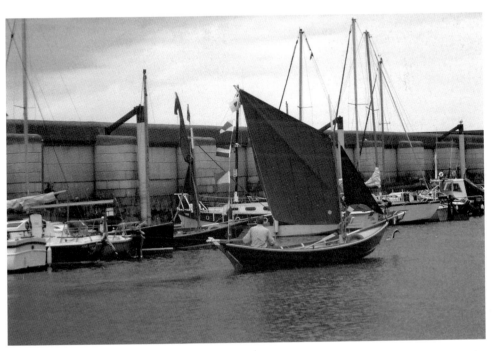

Ostara being sailed for the first time around the harbour. Note *Yankee Jack* moored in the background.

Emmet on the River Tone at the River Festival in 2004, Taunton.

Gil Mayes trying out *John Short* at the 2007 River Festival on the River Tone.

The flatner on the Promenade at Watchet full of flowers. Hundreds of small boats have sadly ended their days in such a way all around the world. Some call this 'saving for posterity', though others say it is part of the 'legalised vandalism' of the decommissioning policy of the ill-fated Common Fisheries Policy!(*Photo by author*)

We started with John Nash; he has contributed most of the contant of this book and so we had better finish with him. Thank you, John. (*Photo by author*)

Bibliography

Anderson, T., *Life on the Levels*, Edinburgh, 2006.

Bagias, Caroline, *Withy, Rush & Reed*, Tiverton, 2003.

Crowden, J. & Rook, P., *Bridgwater – the Parret's Mouth*, Bridport, 2000.

Dunning, R.W., *A History of Someset*, Bridgwater, 1978.

Farr, Graham, *Somerset Harbours*, London, 1954.

Fletcher, Ken, *The Somerset Levels & Moors*, Tiverton, 1991.

Greenhill, Basil, *The Archaeology of Boats and Ships*, London, 1995.

Haskell, Tony, *By Waterway to Taunton*, Tiverton, 1994.

Hunt, T. J. & Sellman, R. R., *Aspects of Somerset History*, Taunton, 1973.

James, Tony, *Yankee Jack Sails Again*, Rendlesham, 2006.

Major, Albany, *Early History of Wessex*, Cambridge, 1913.

Mannering, J. (ed), *Chatham Directory of Inshore Craft*, London, 1997.

McKee, Eric, *Working Boats of Britain*, London, 1983.

McKee, J. G., 'The Weston-super-Mare Flatner' in *The Mariner's Mirror*, Vol. 57, 1971, No. 1, pages 25–39.

Sutherland, P., *Wetland – Life in the Somerset Levels*, London, 1986.

Waters, Brian, *The Bristol Channel*, London, 1955.

Willoughby, Chris, *Somerset*, Stroud, 1993.

Places to visit

Watchet Boat Museum, Watchet

Brick and Tile Museum, Bridgwater

Willows & Wetlands Centre, Stoke St Gregory

Cider farms such as Sheppy's of Bradford-on-Tone, Coombes of Mark and Perrys Cider of Dowlish Wake have small museums

Museum of Rural Life, Glastonbury (displays including cheese making)